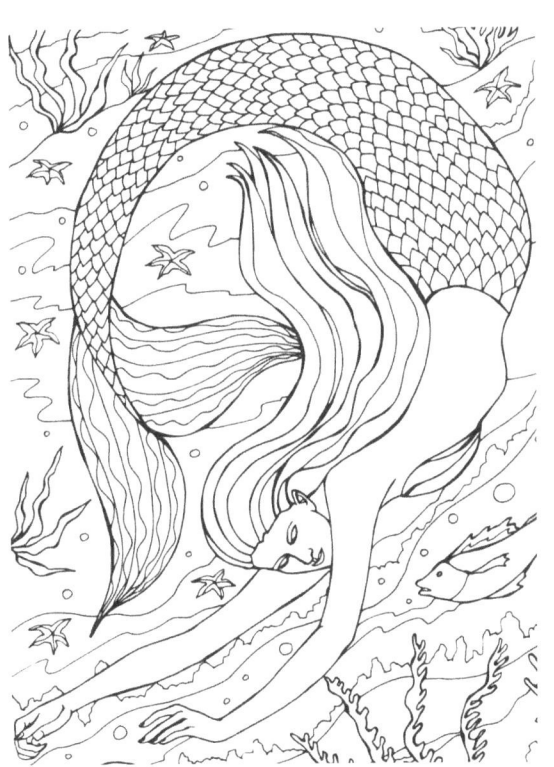

For my parents

Suhasini and Vilas Panse

and my grandparents

Indumati and Vasudeo Panse

Text, Illustrations, Design, and Typography Copyright © 2016 by Sonal Panse.

All rights reserved, including the right of reproduction in whole or in part, in any form, in any format, now known or still to be invented.

This book may not be reproduced, in whole or in part, in any manner, without written permission from Sonal Panse.

This edition published 2016 by Maysun In C.

The Illustrations are in Pen and Ink.

Text, Illustrations, Cover Design, and Page Design by Sonal Panse.

Visit us at www.maysuninc.com

THE MERMAIDS OF QUIRLY

A Coloring Book

Text and Illustrations by Sonal Panse

A Maysun In C Publication

The land of Quirly lies far, far away.

It is a land touched by bright sunlight

And it is renowned for the warm hospitality of its people

And the unparalleled beauty of their flourishing gardens.

If you ever get the chance to visit, you should.

The black and white images were created organically.

That is, while keeping the theme in mind,

there was no pre-planning, the drawings were allowed to evolve line by line.

I hope you enjoy coloring these pages.

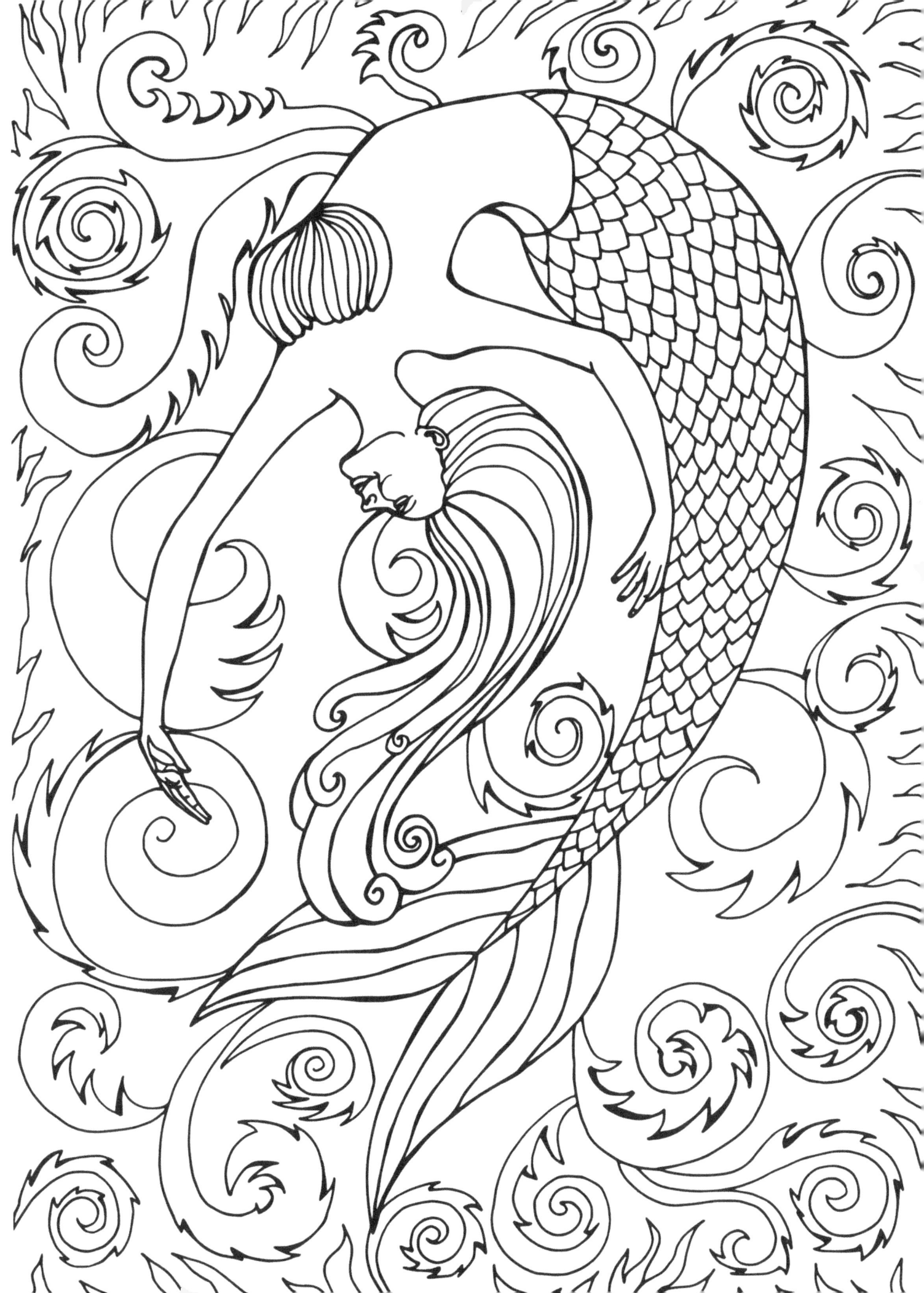

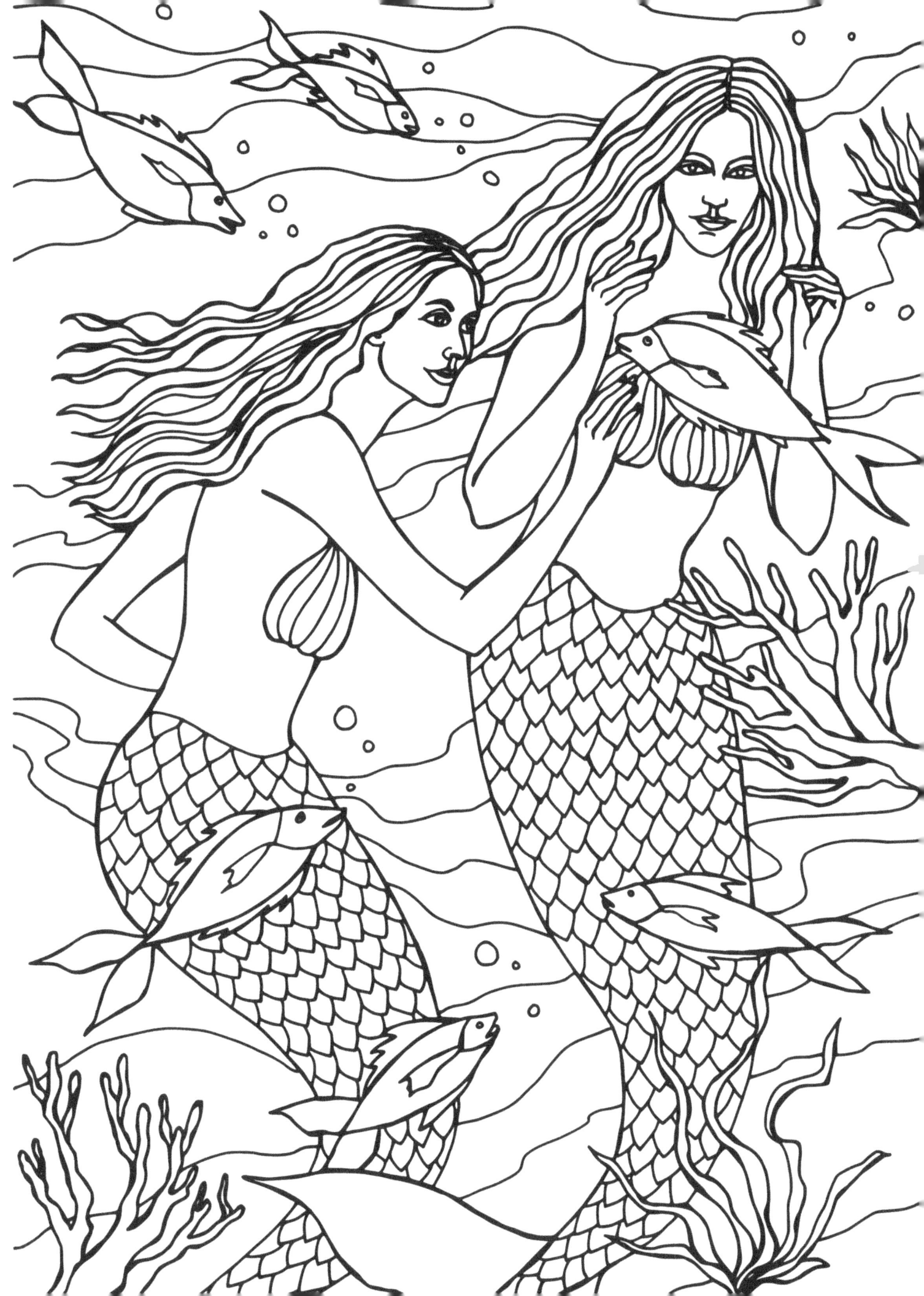

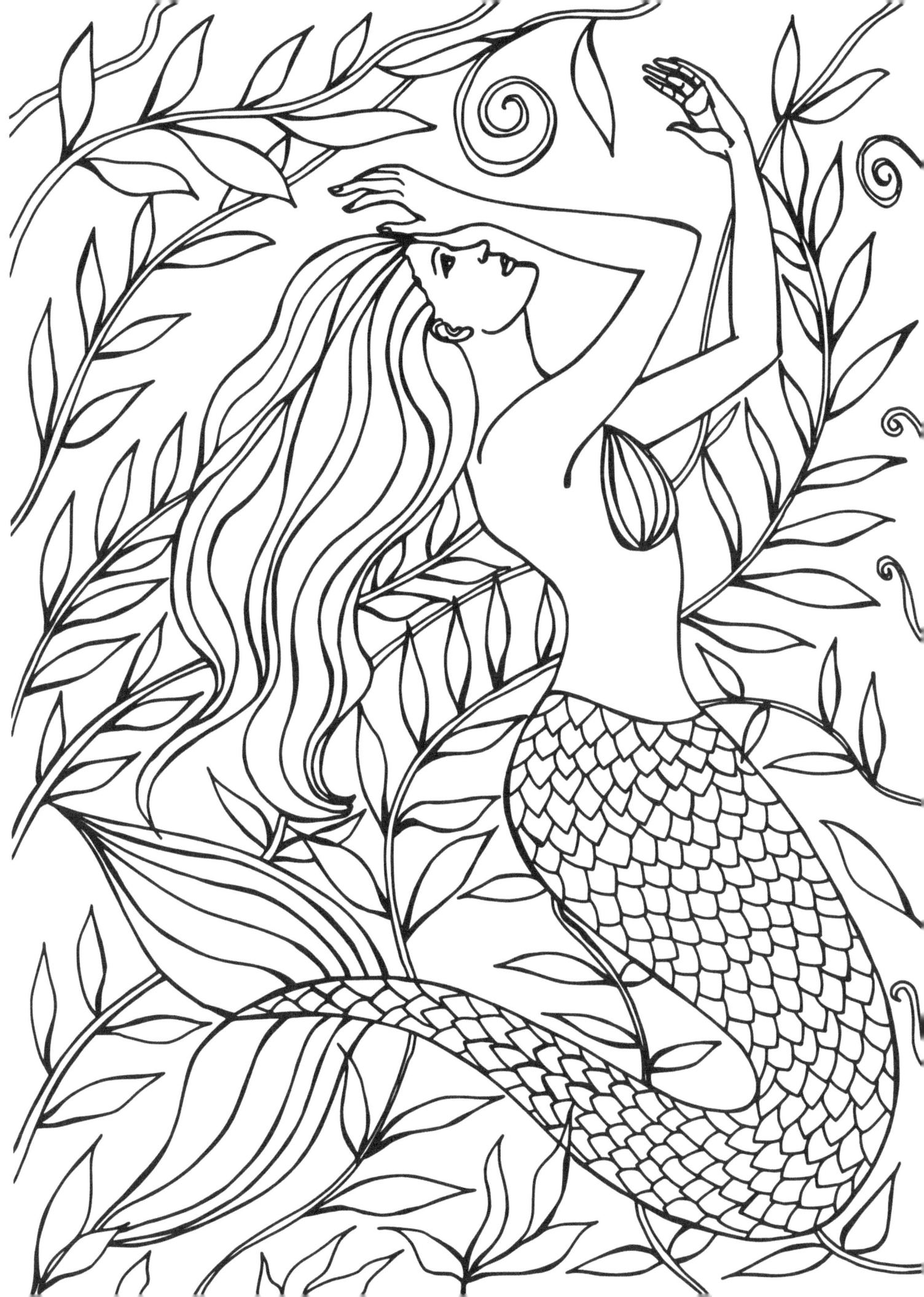

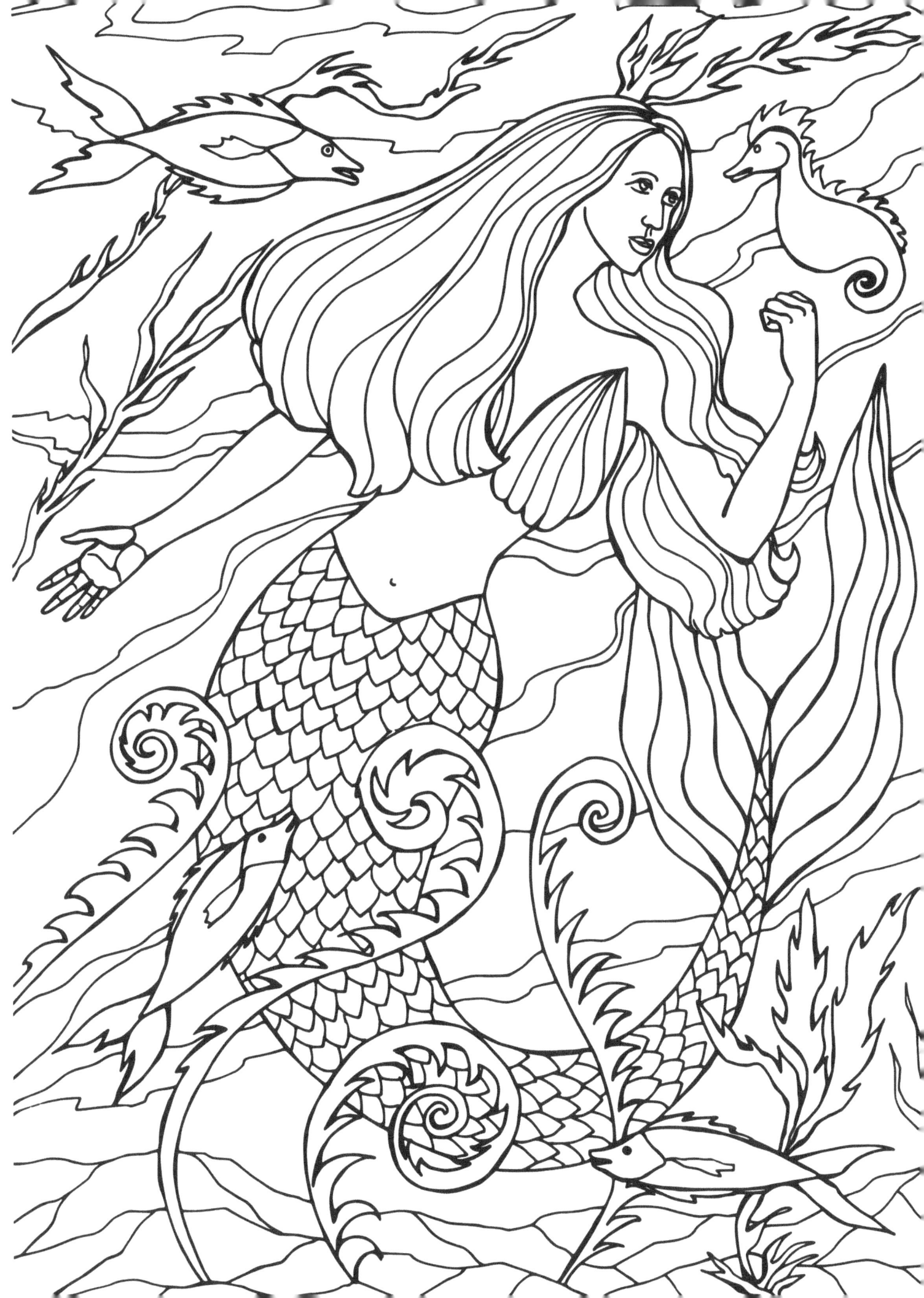

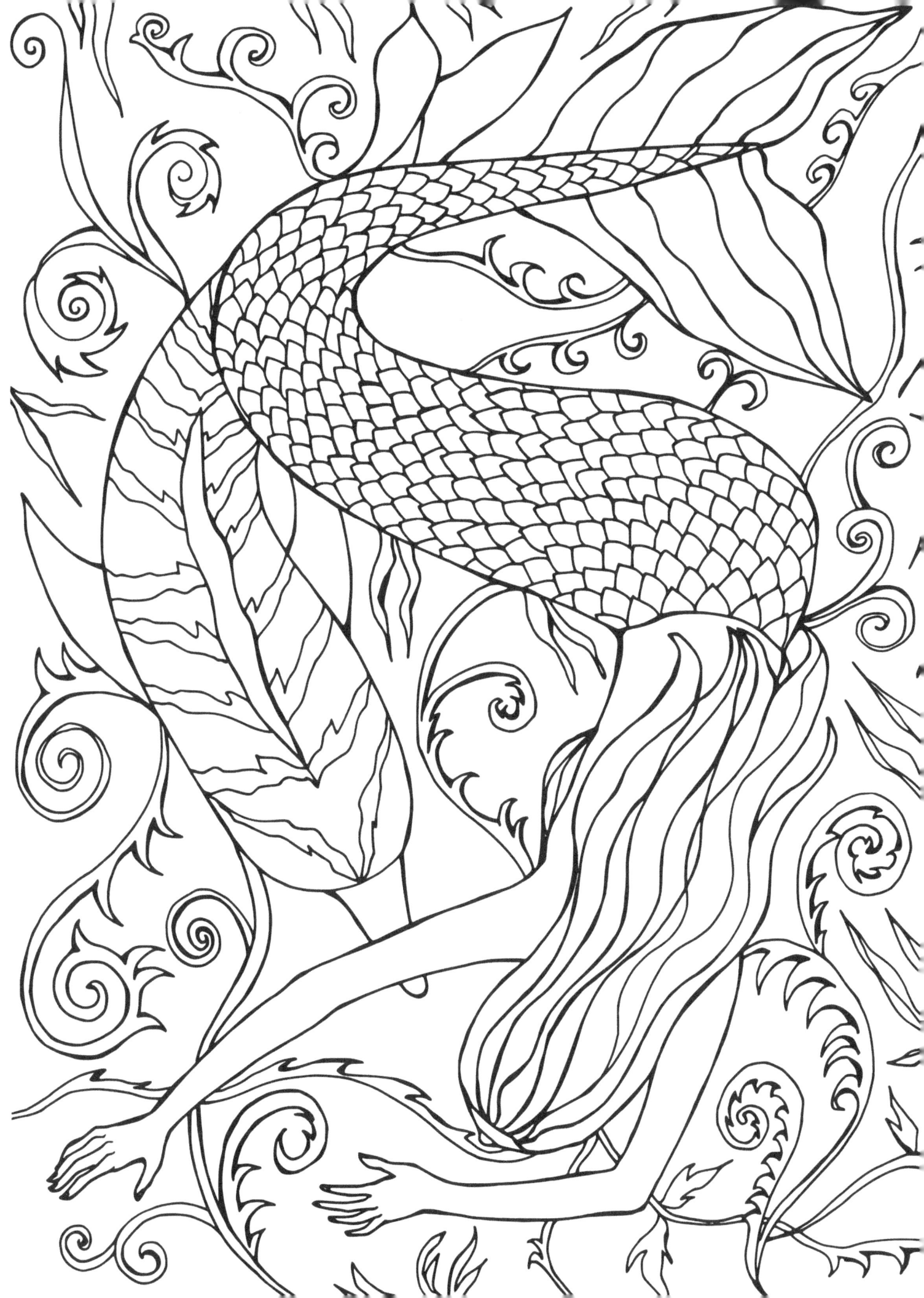

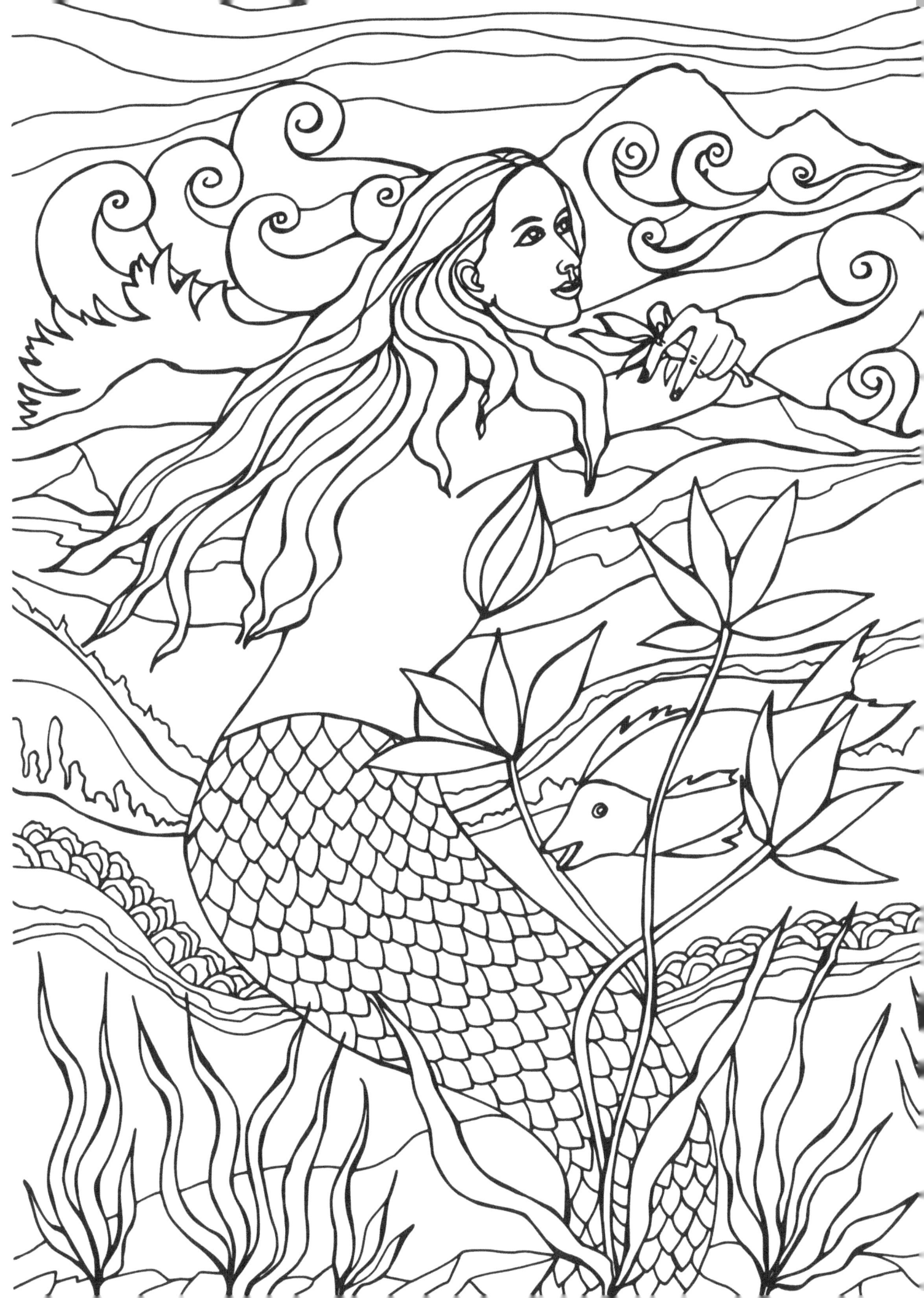

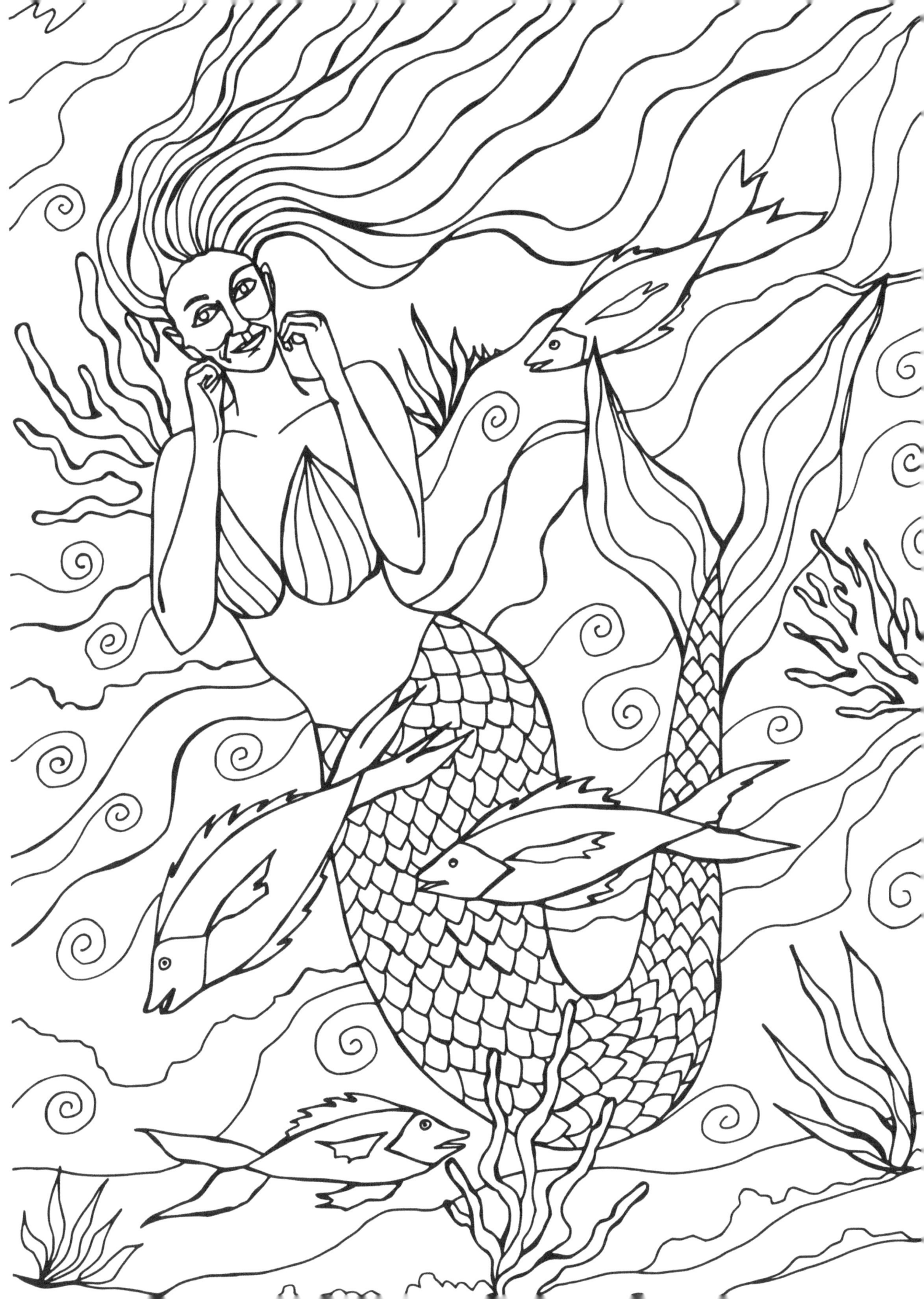

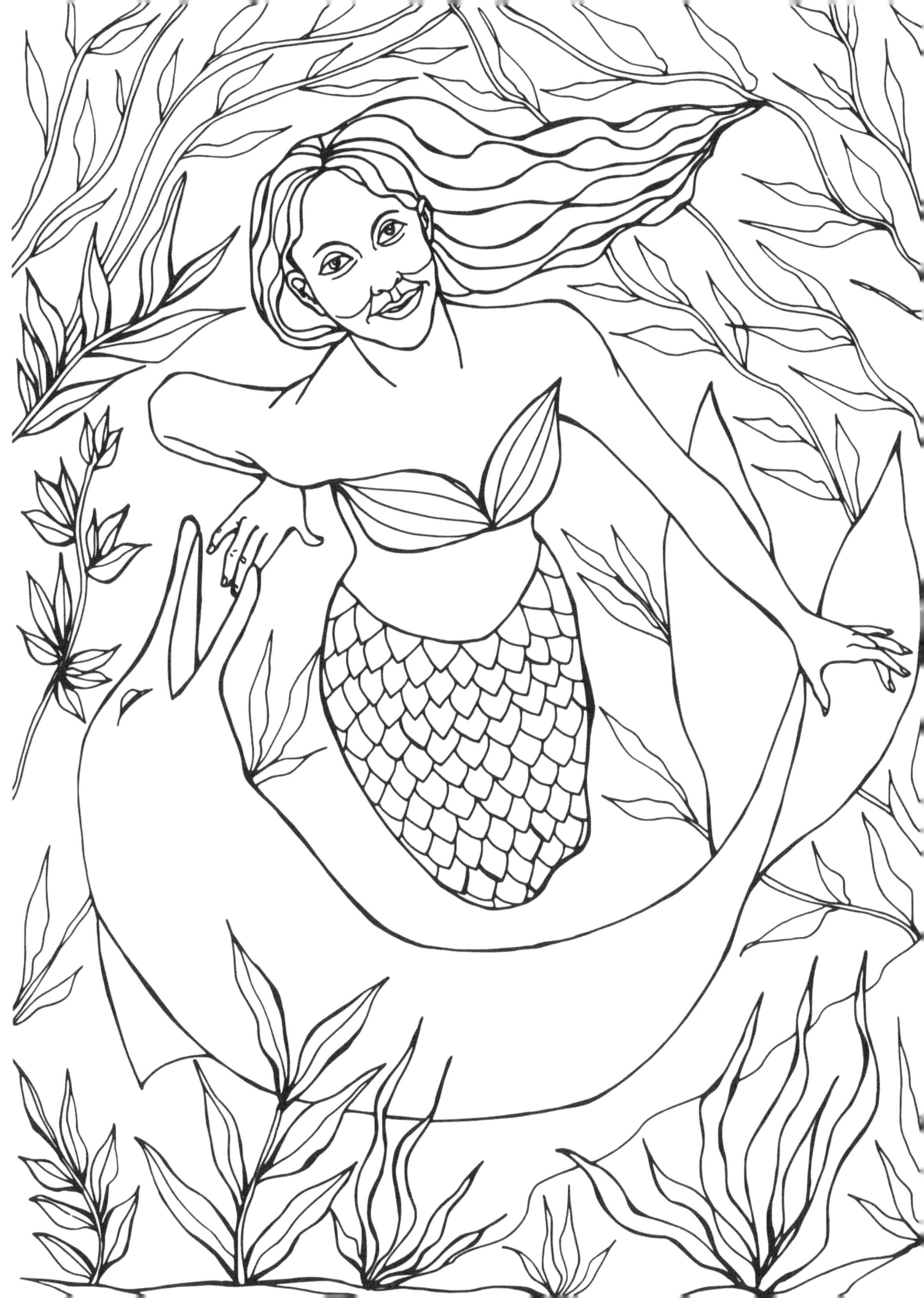

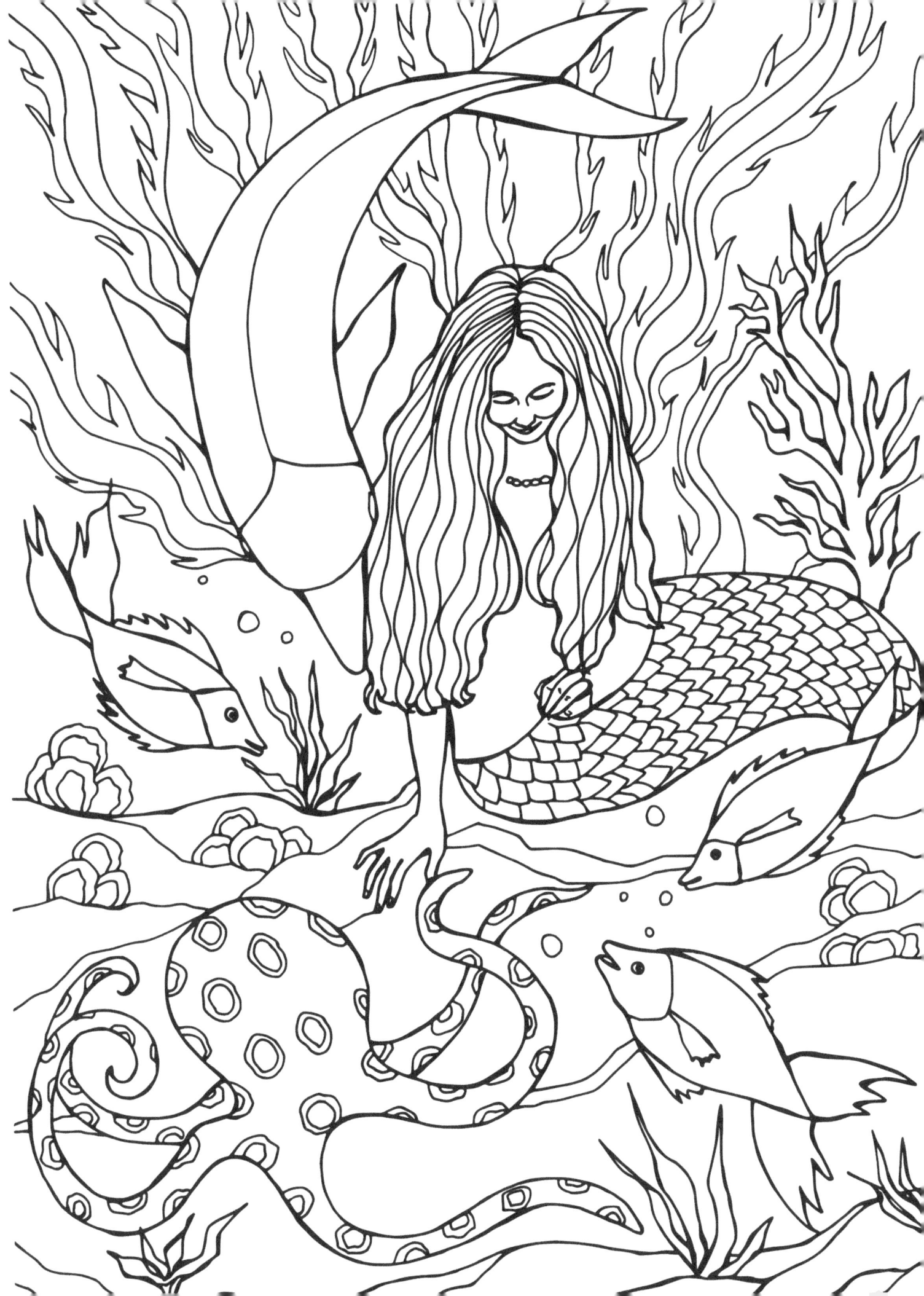

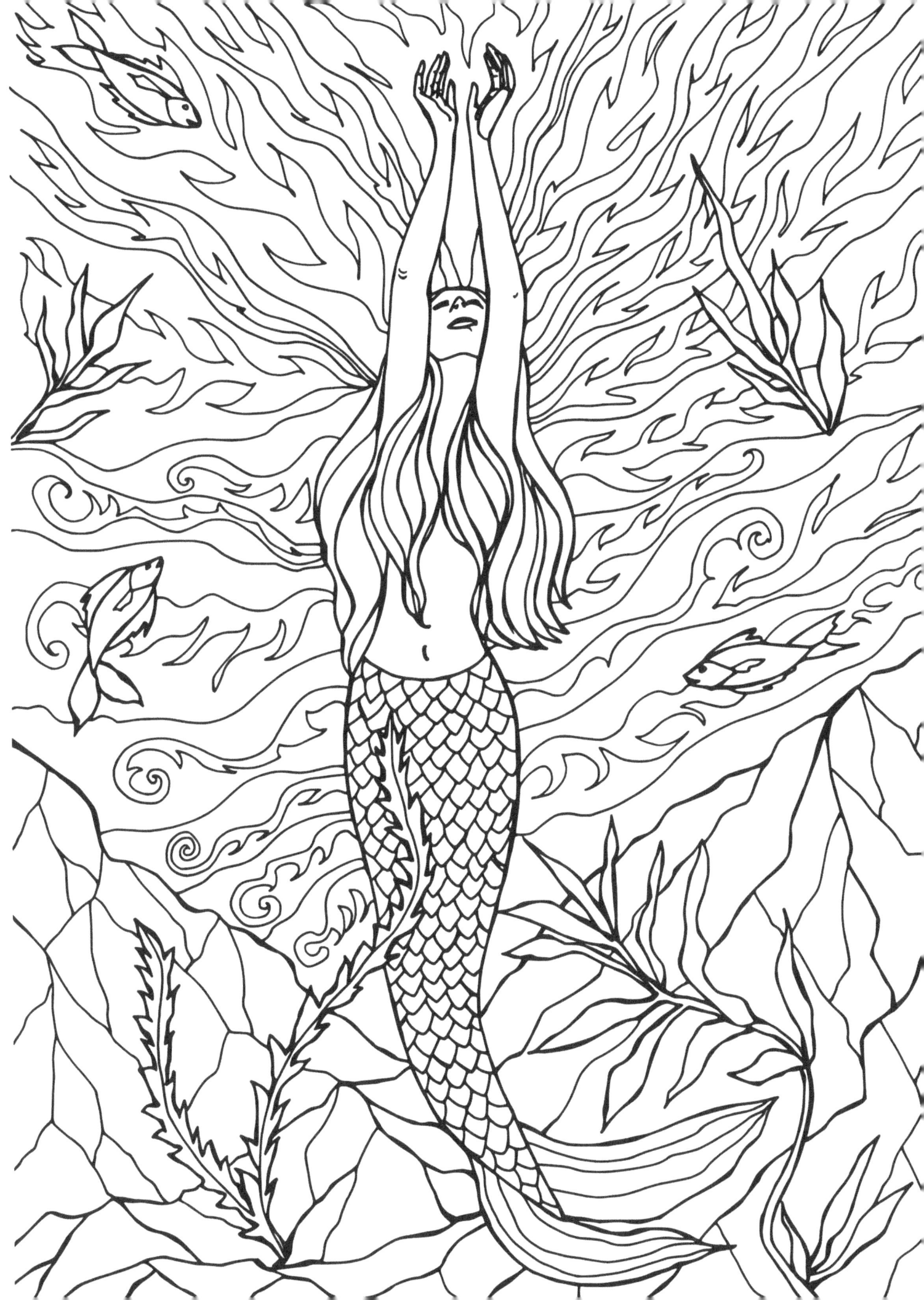

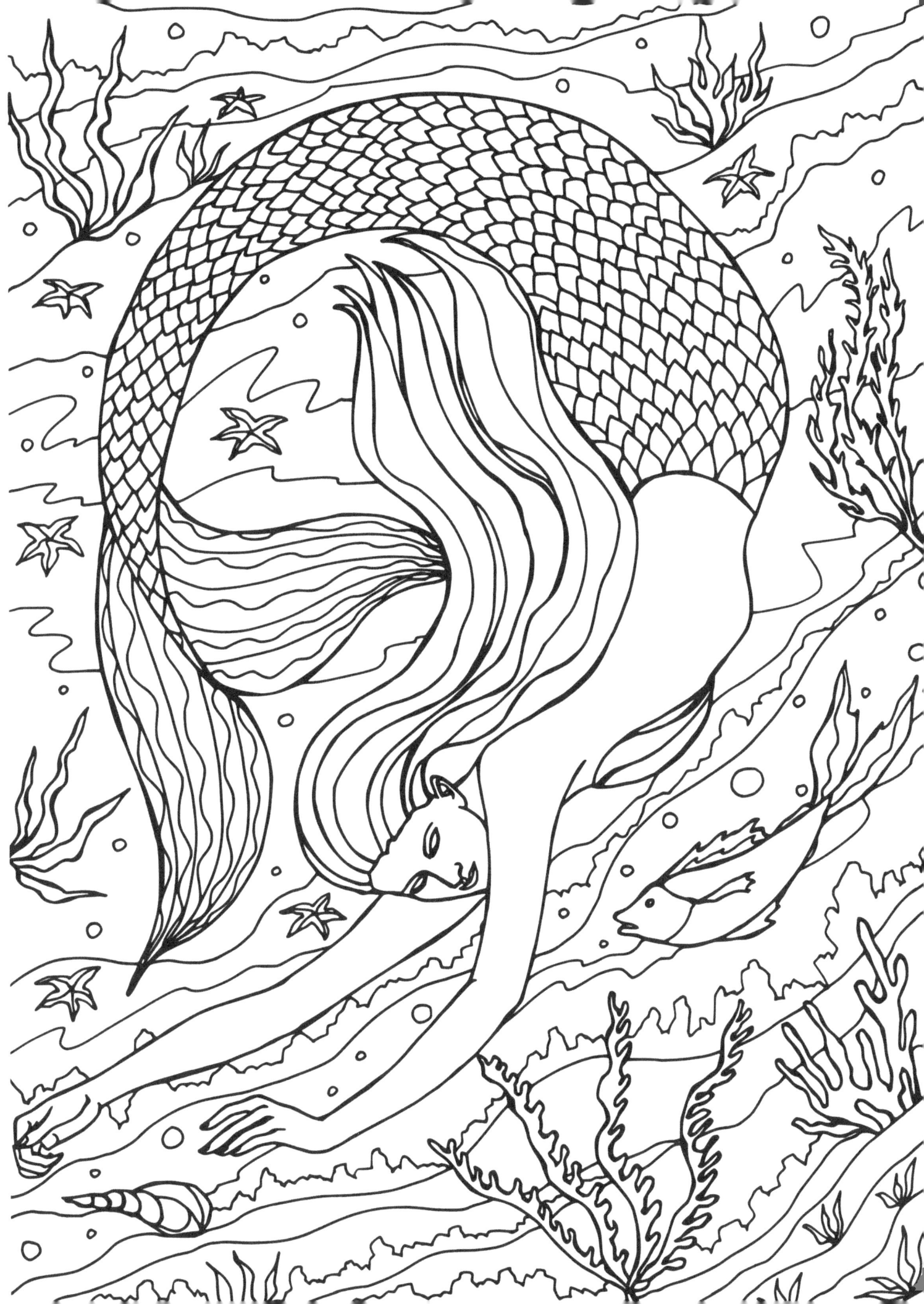

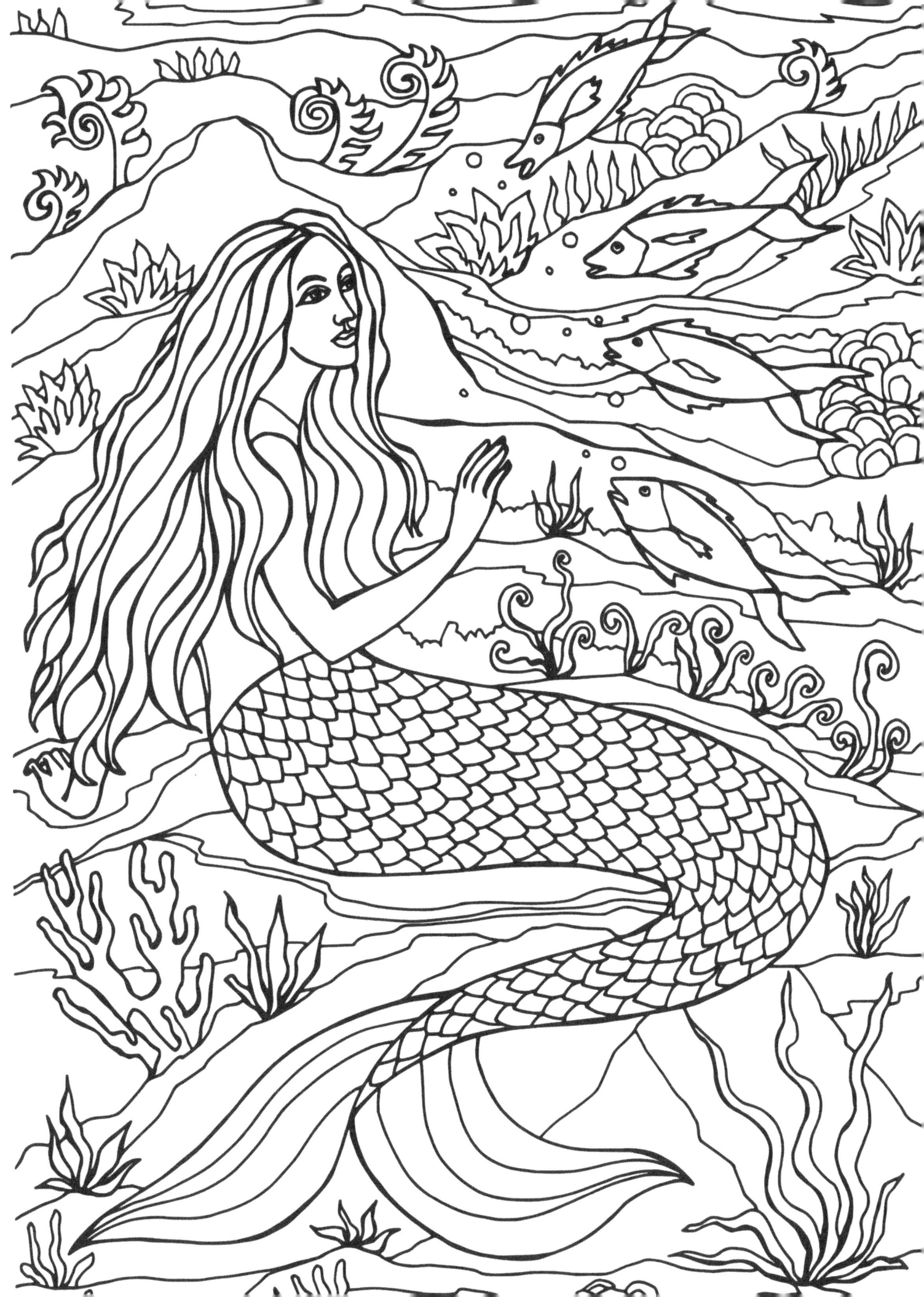

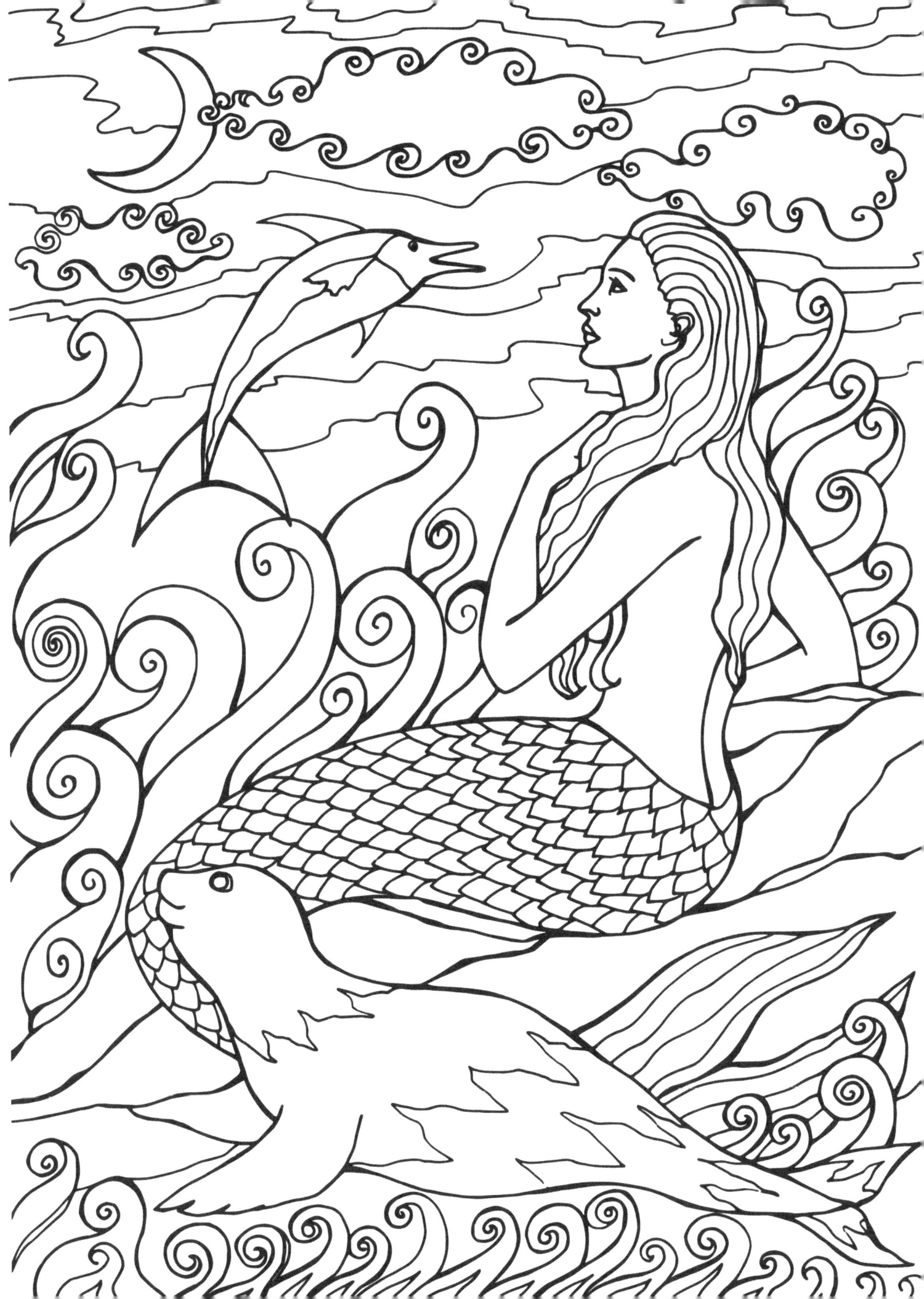

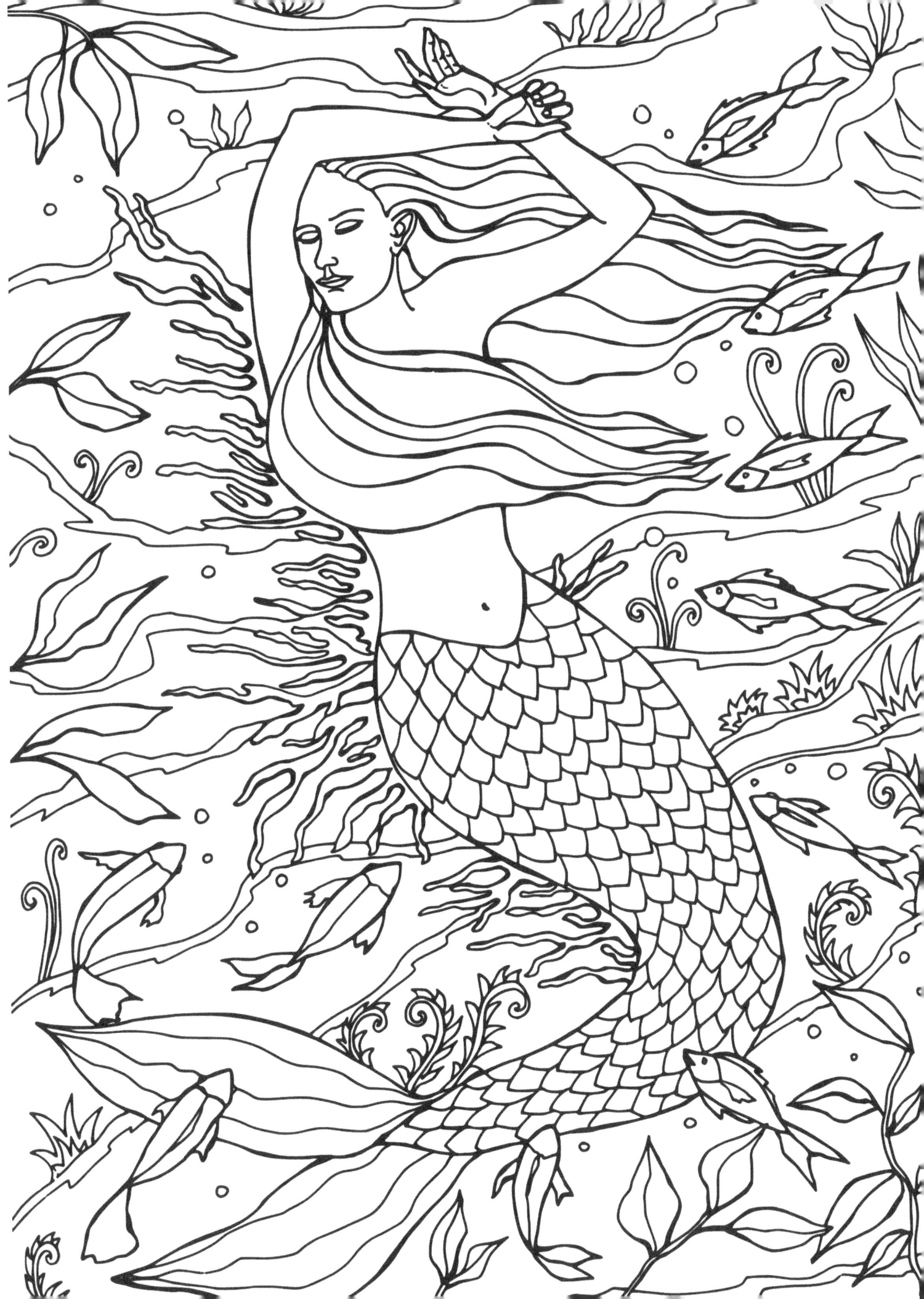

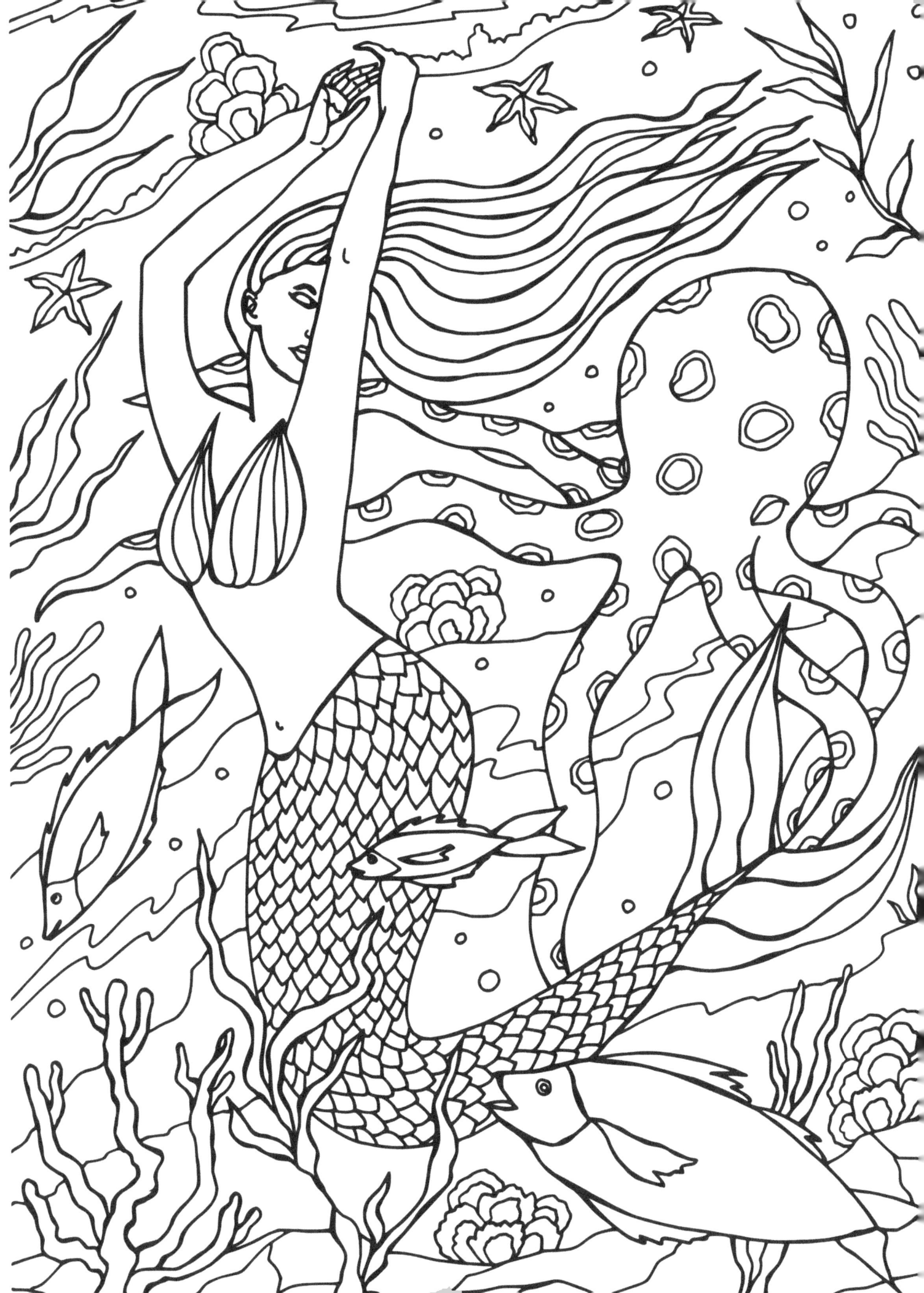

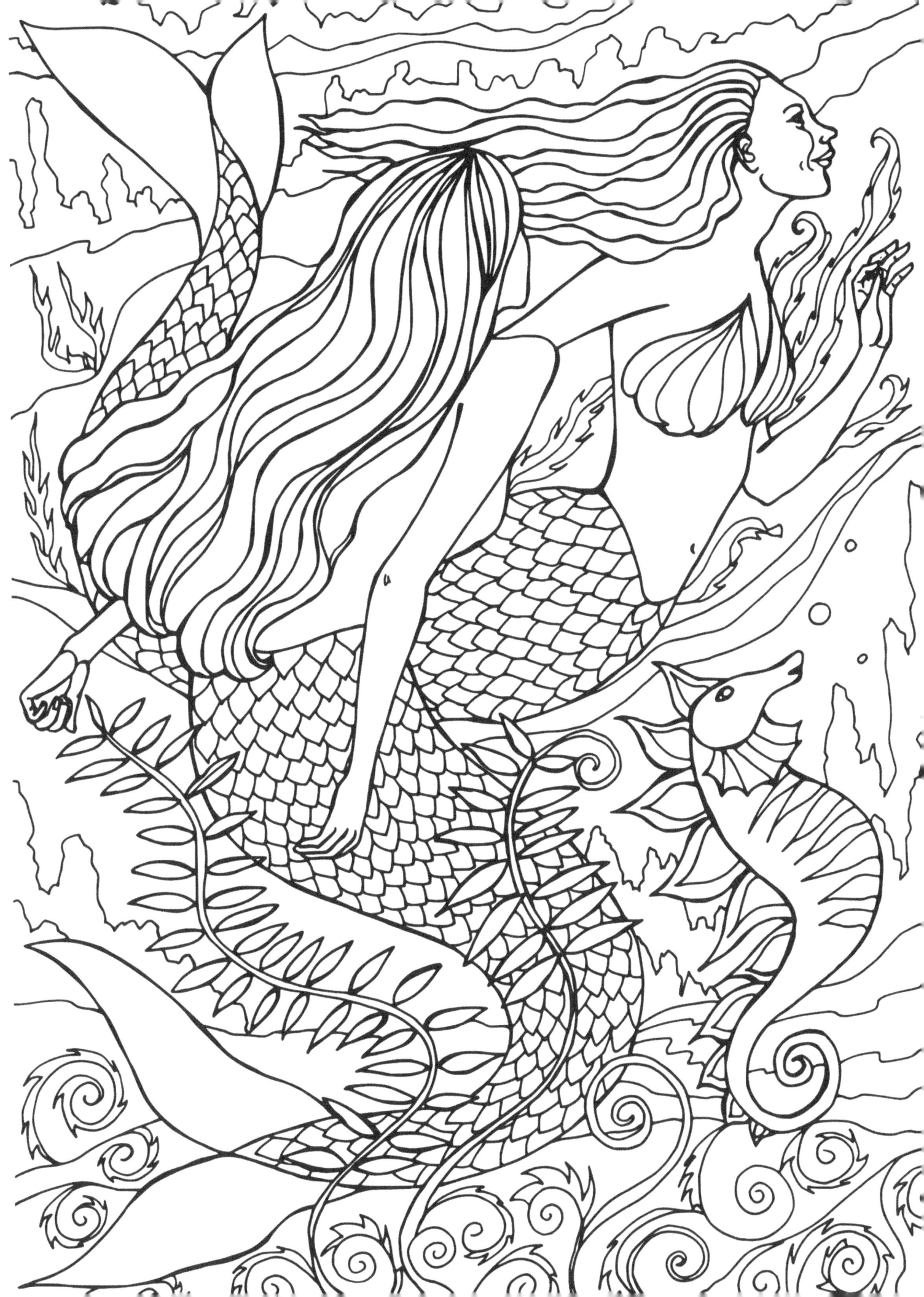

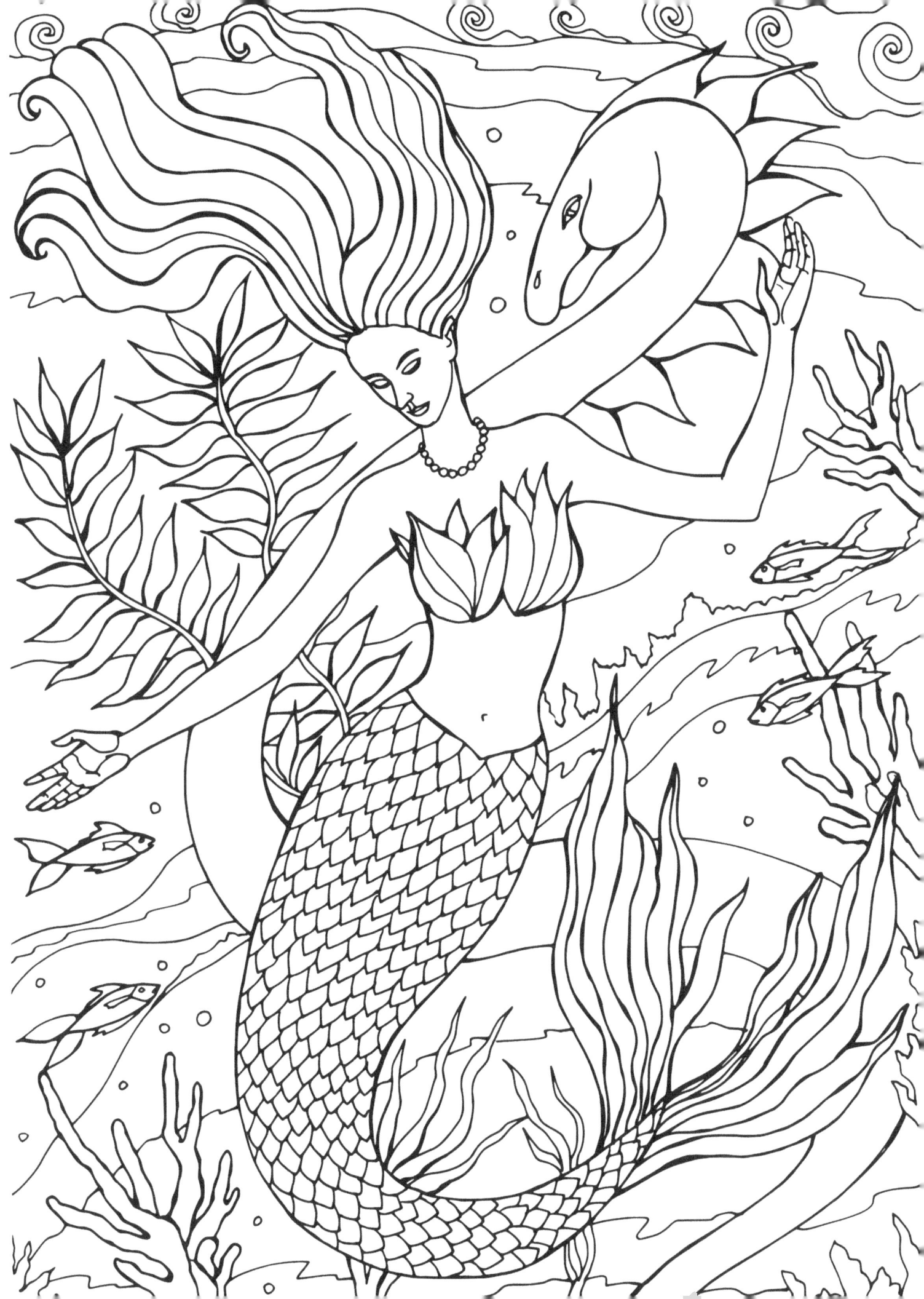

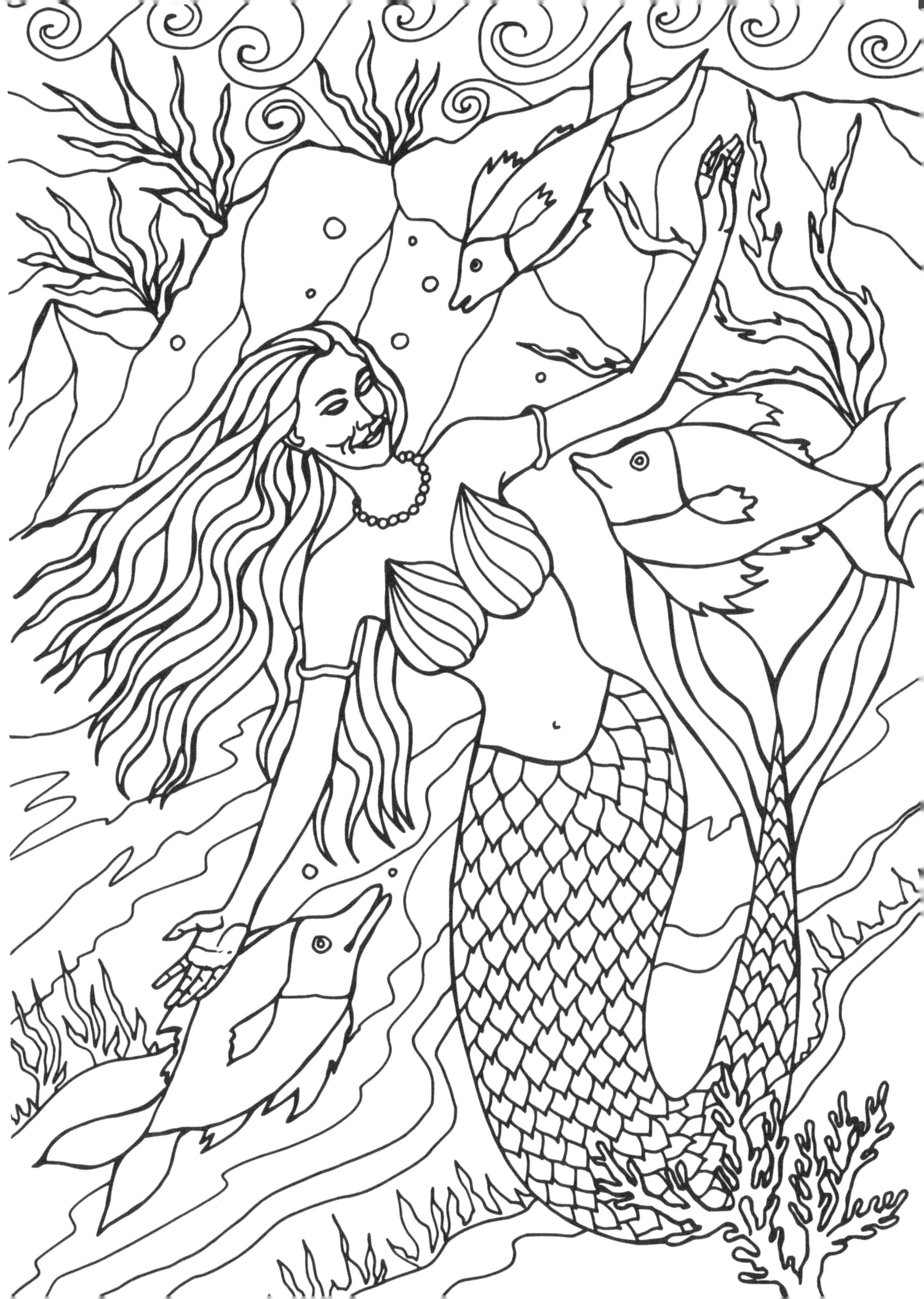

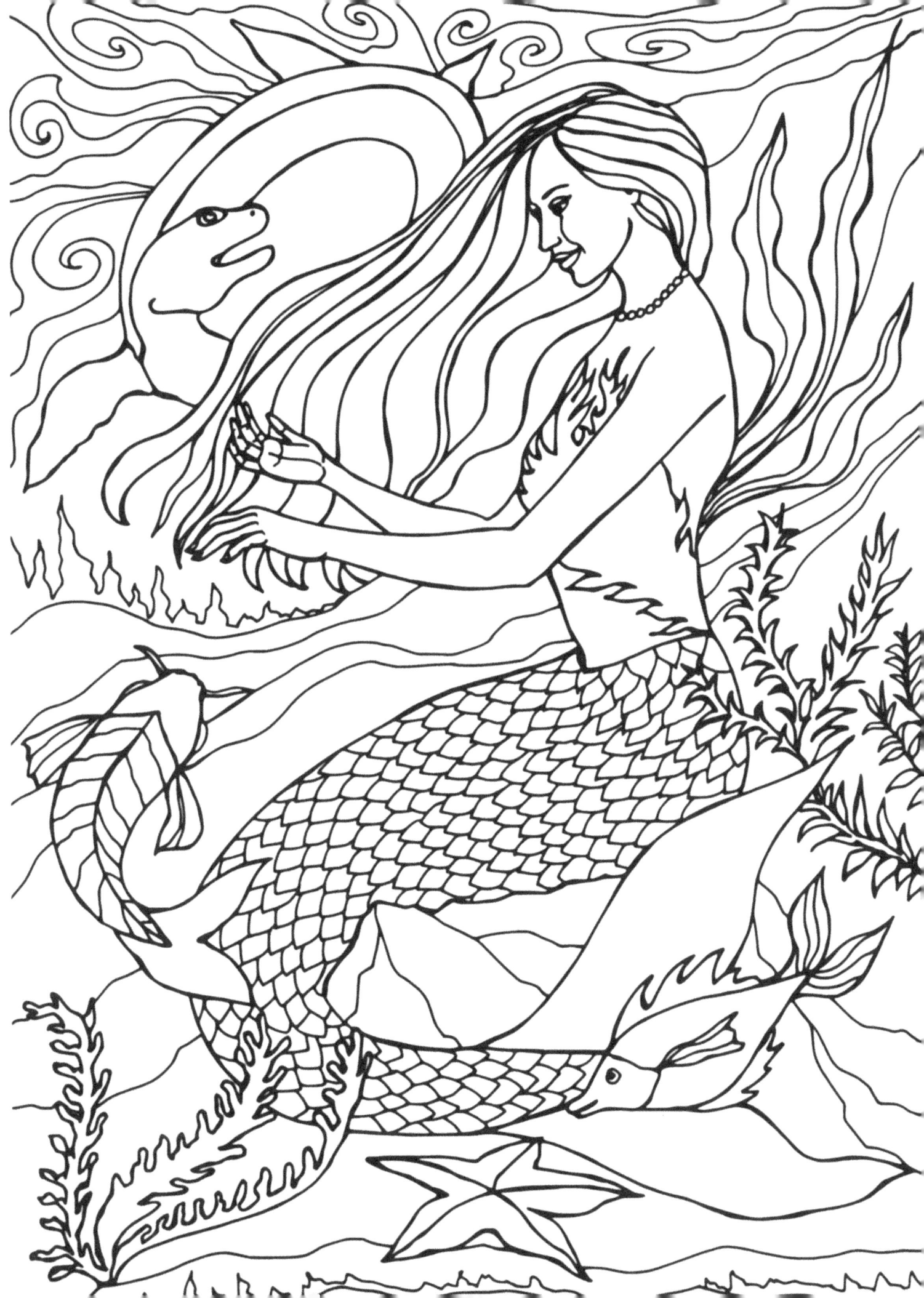

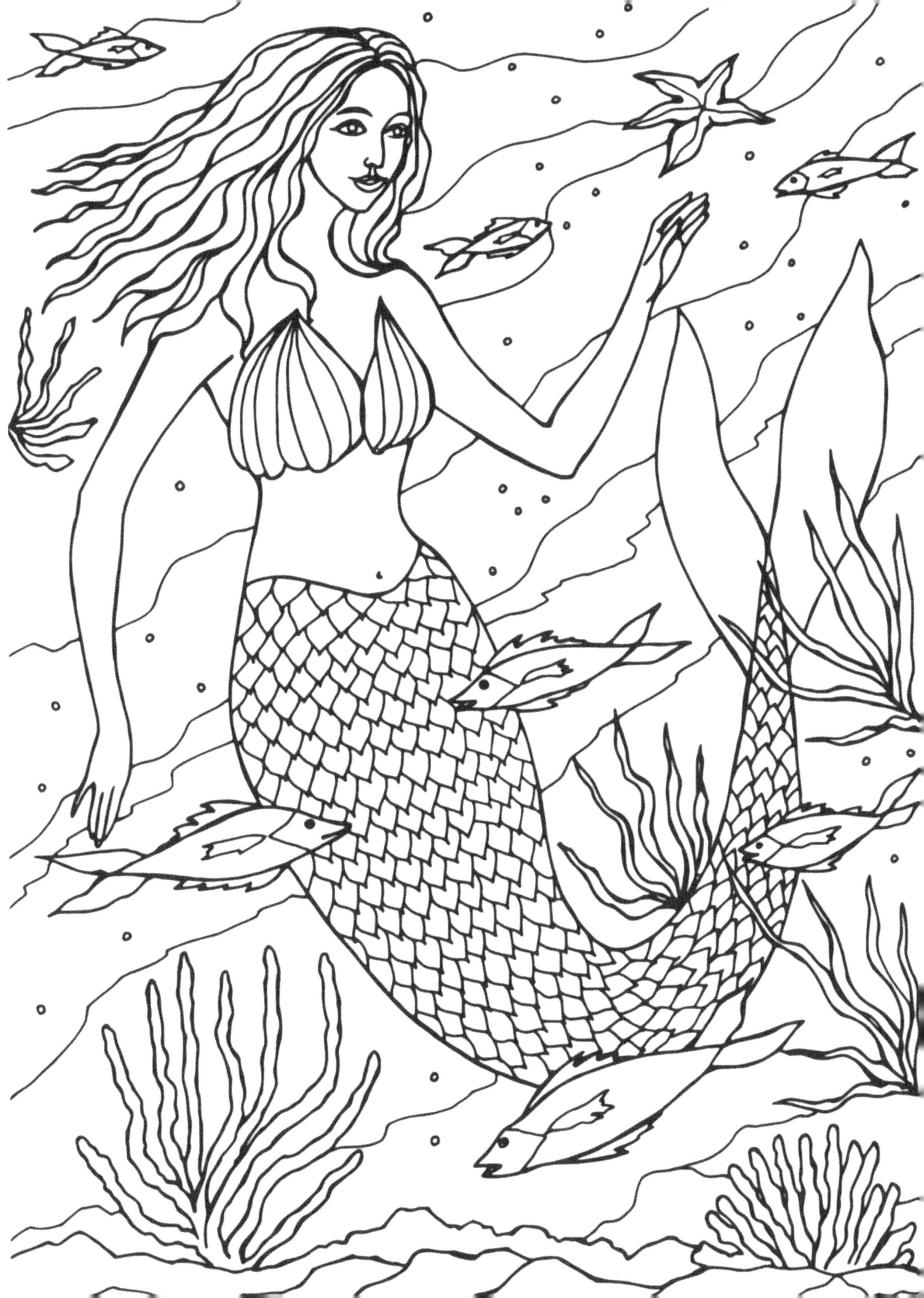

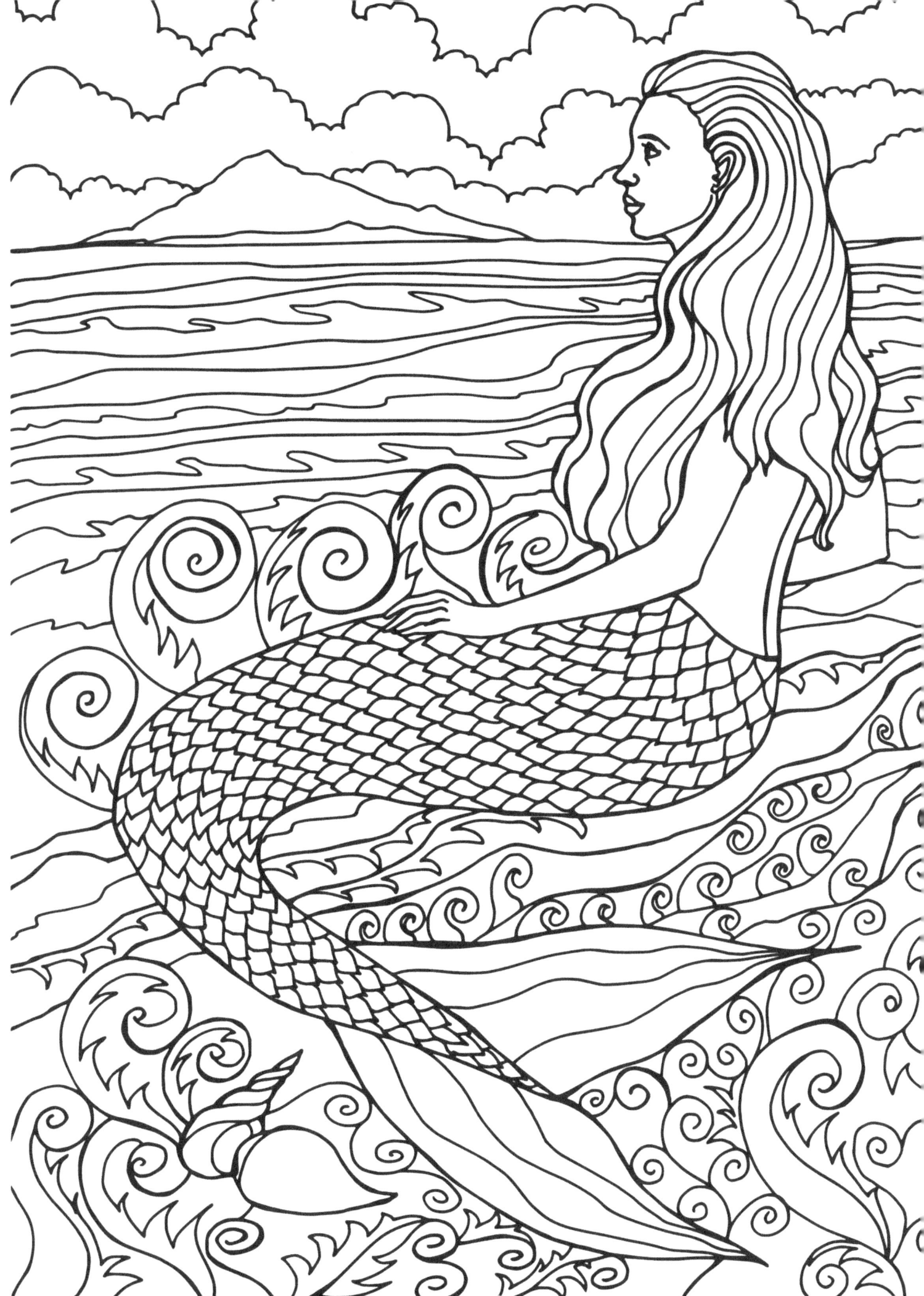

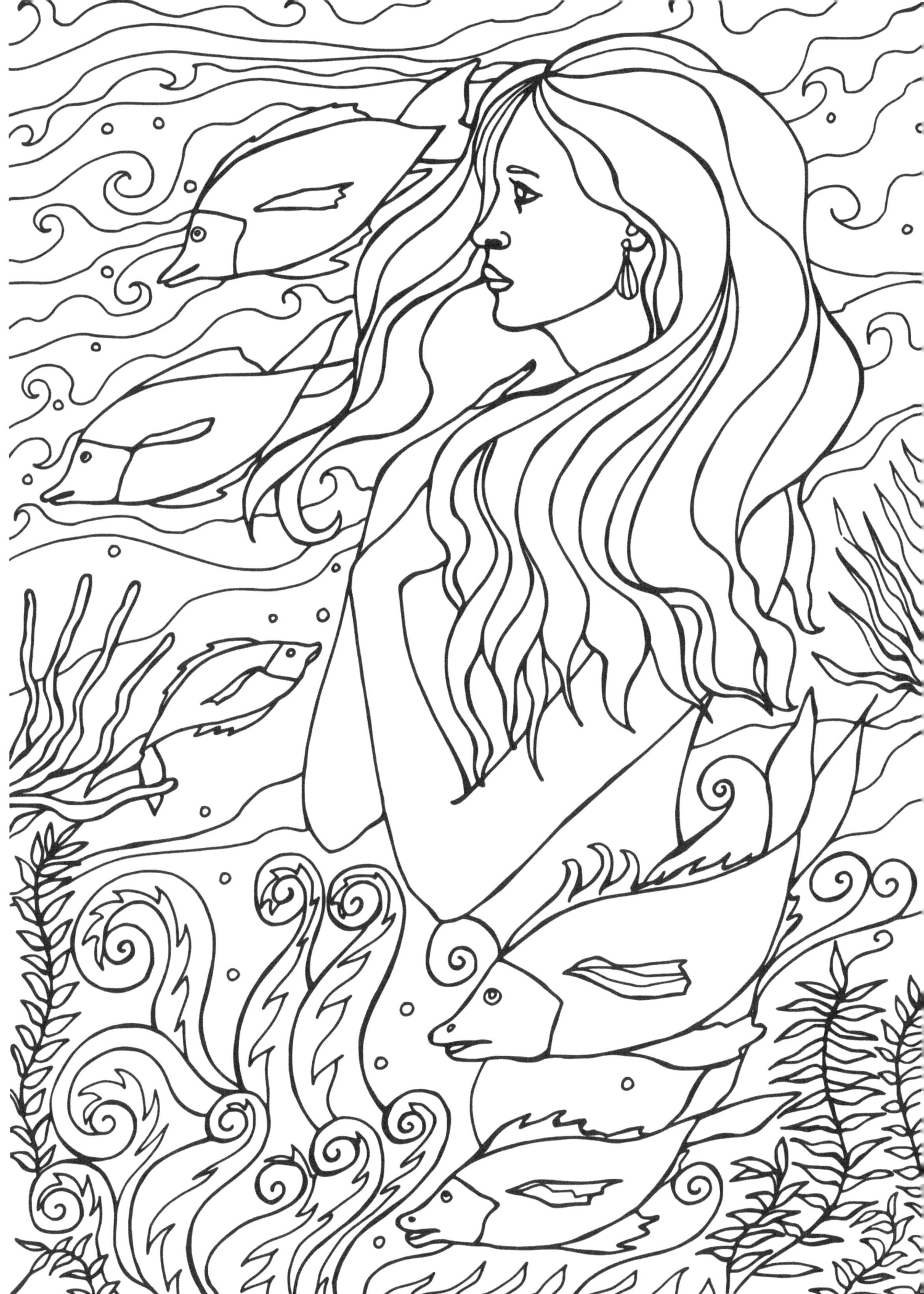

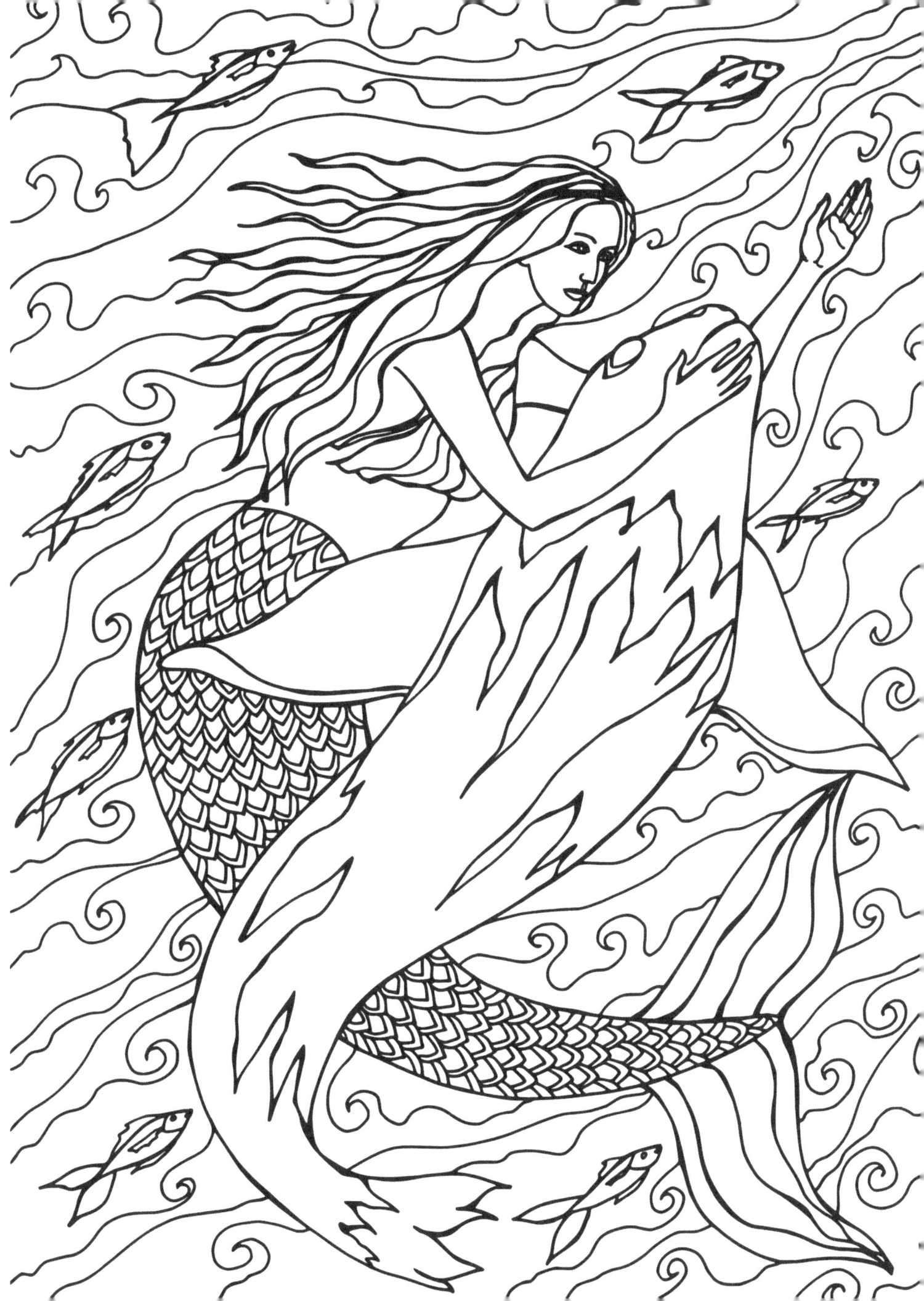

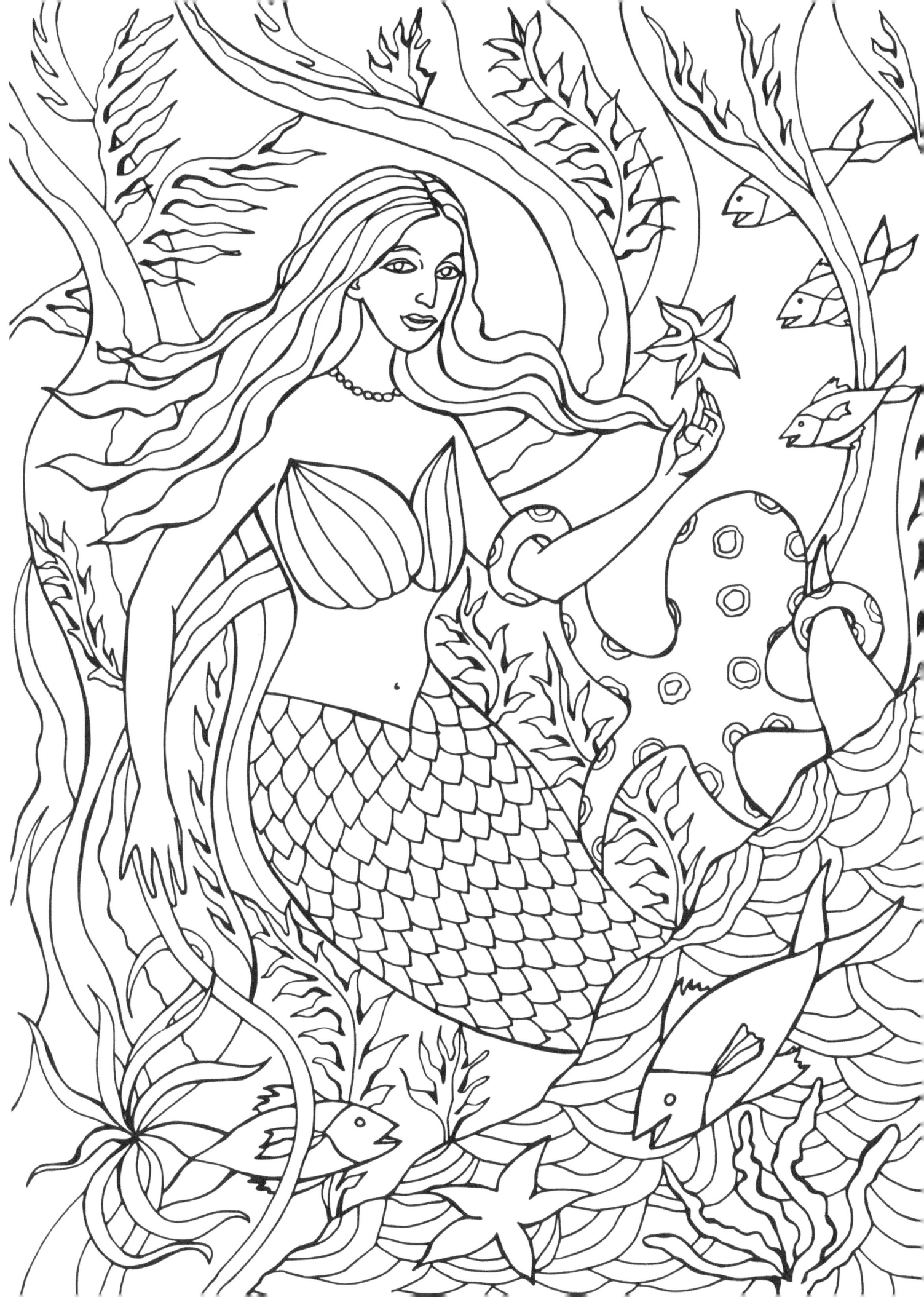

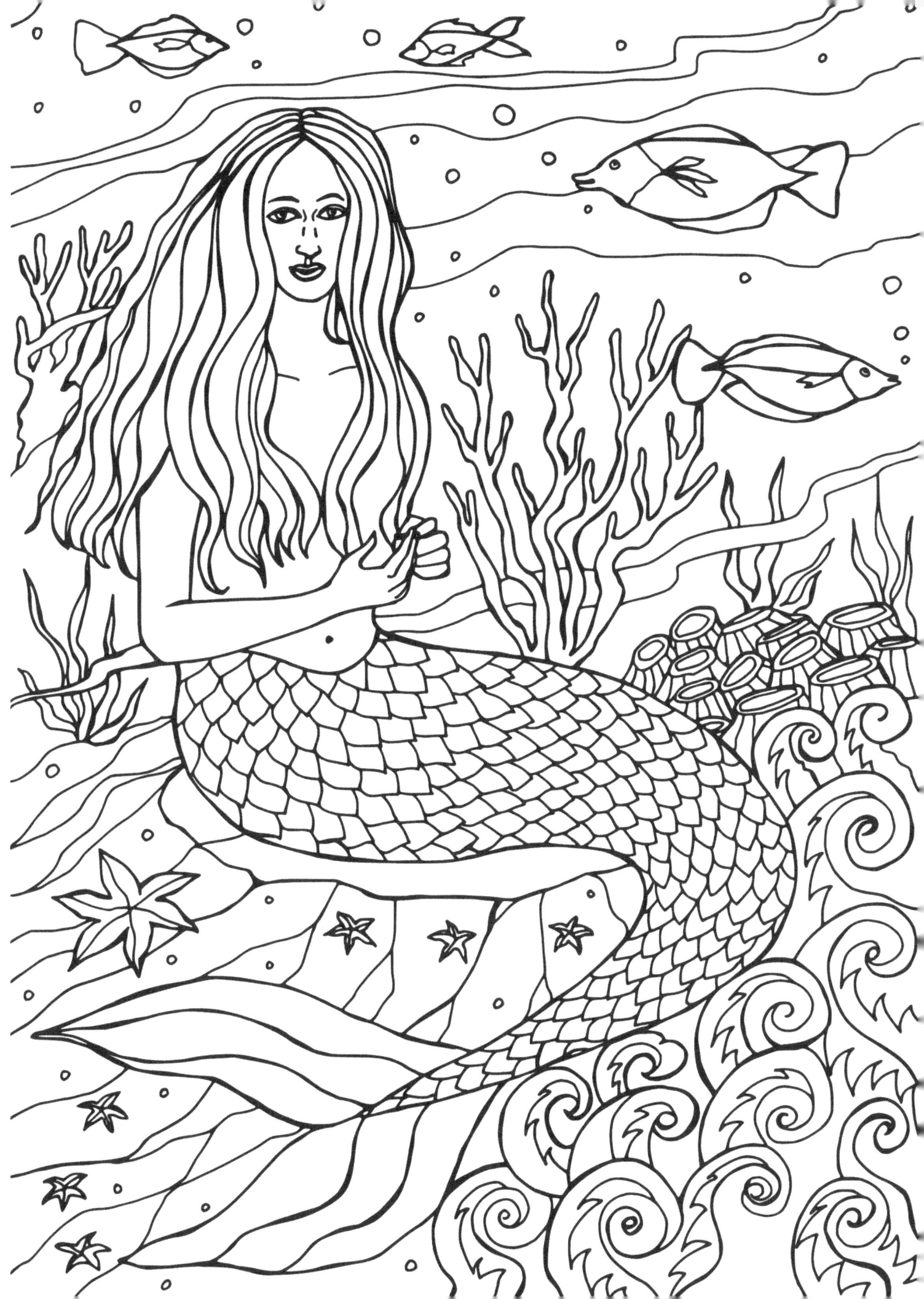

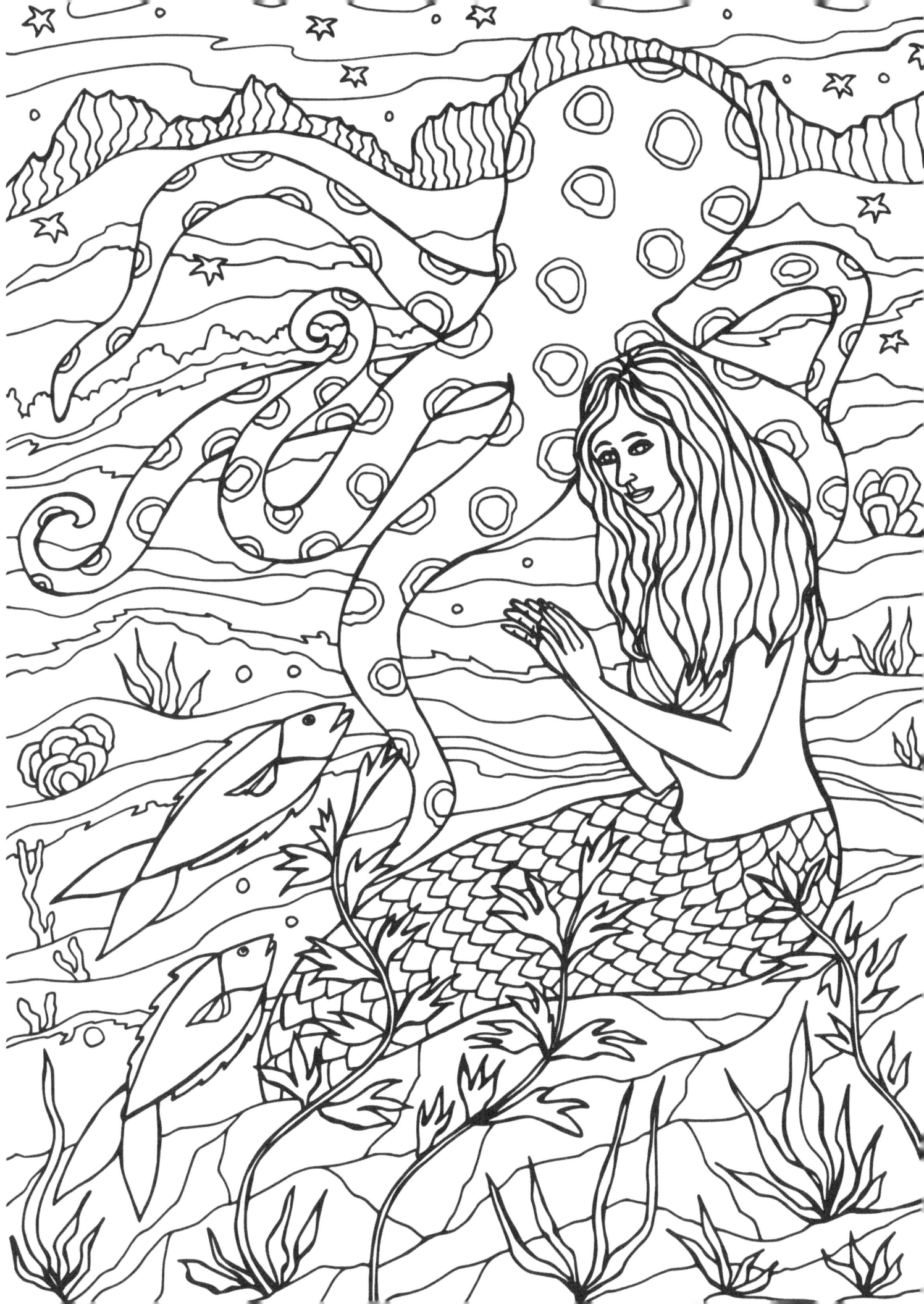

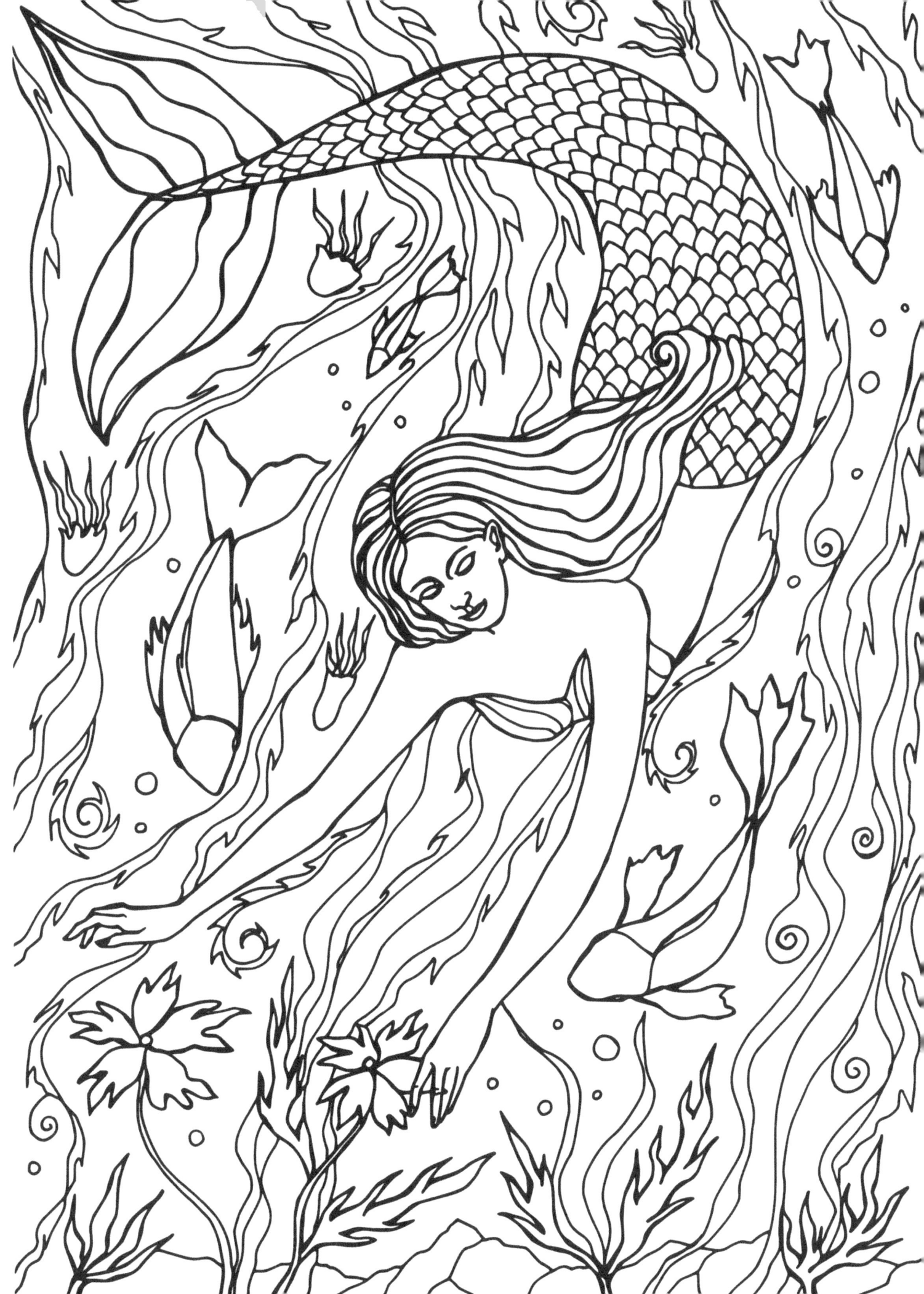

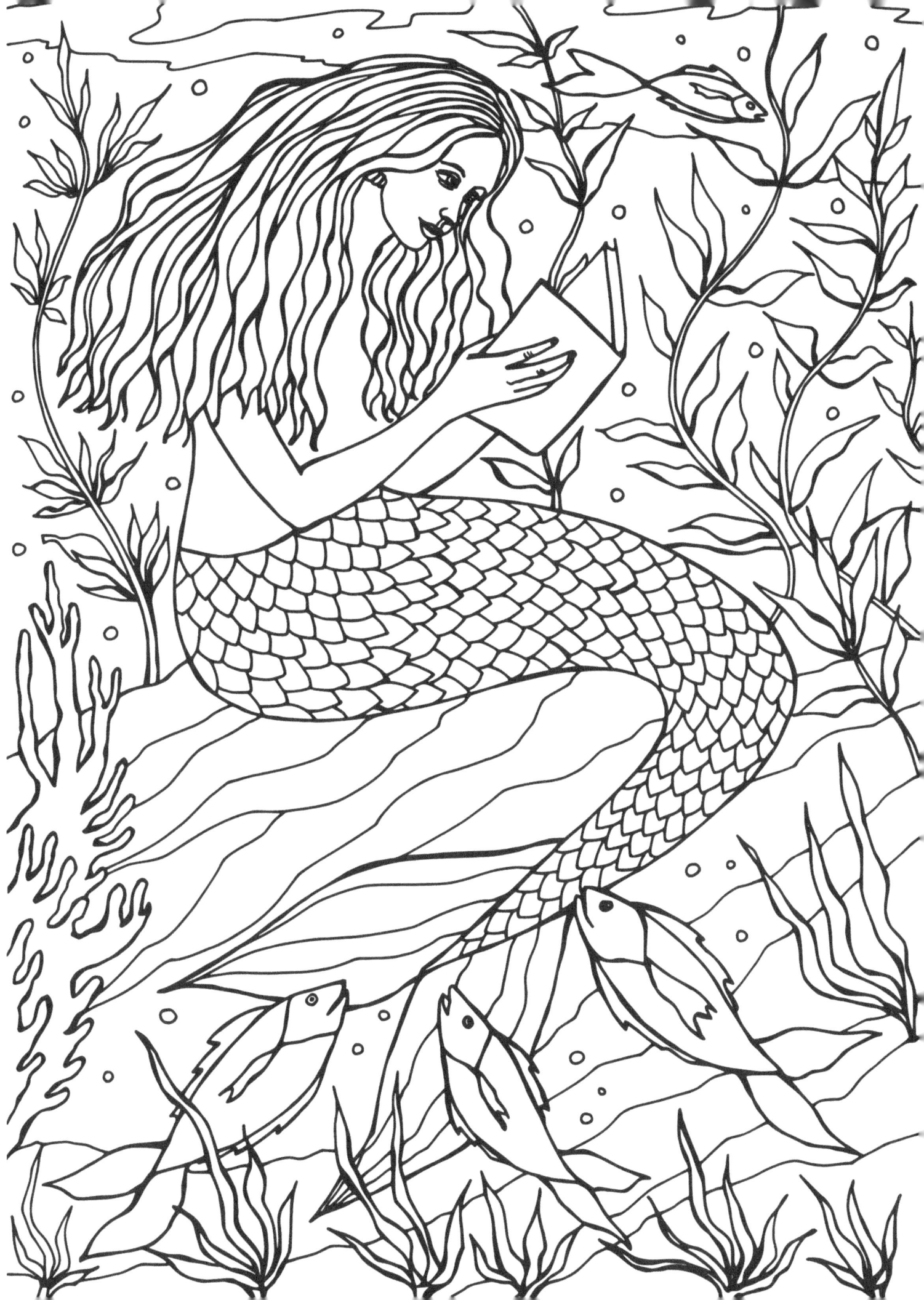

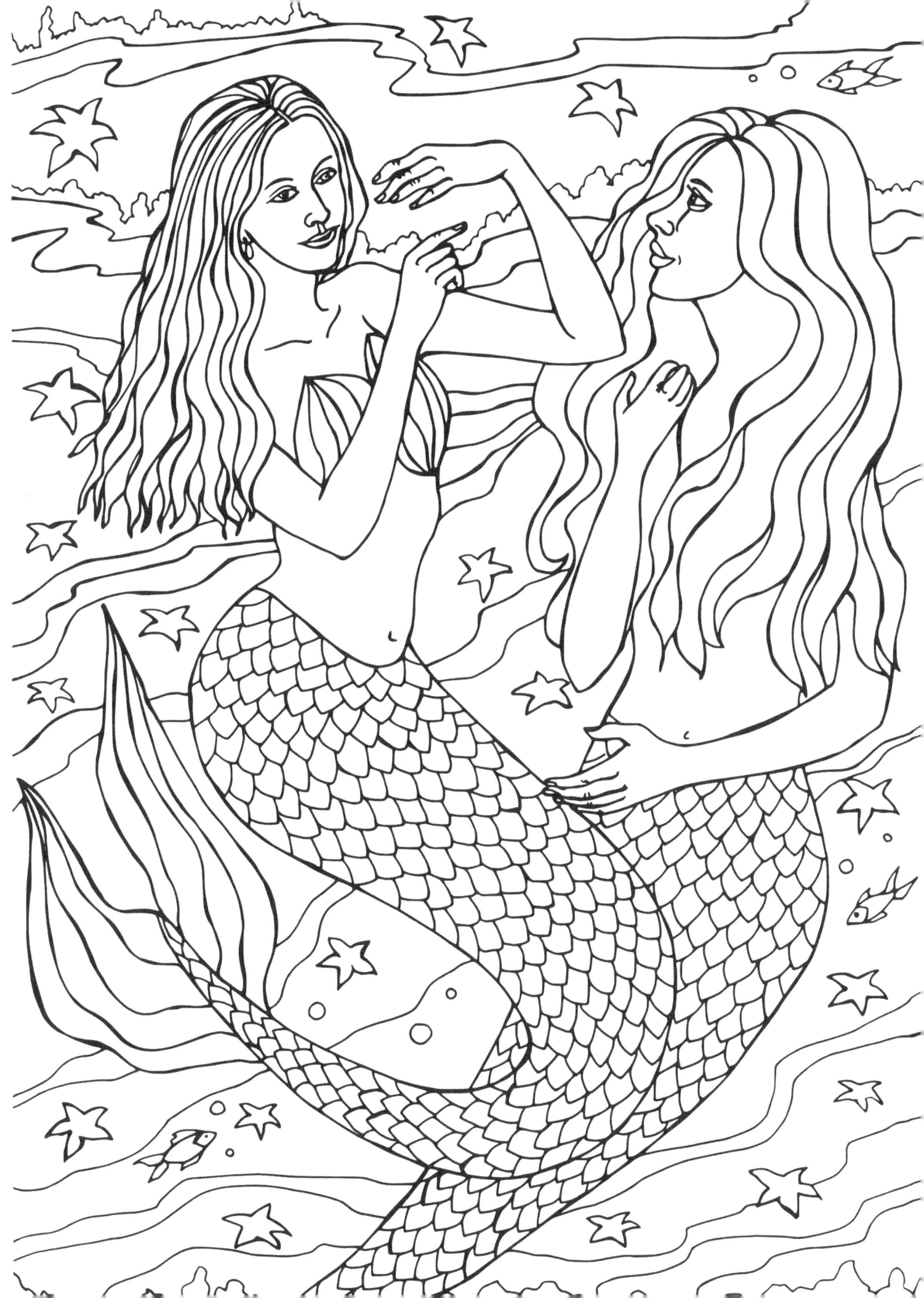

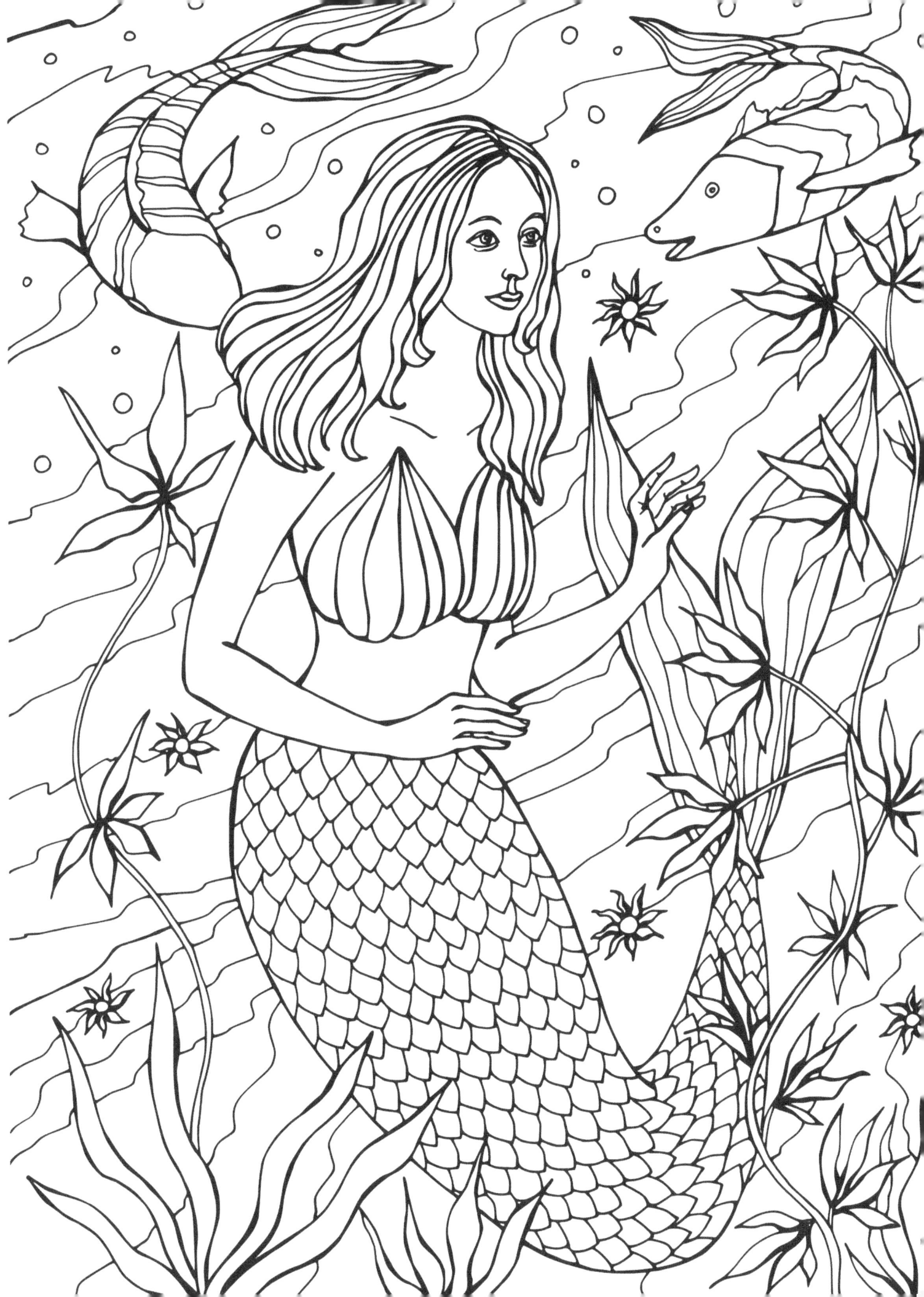

About Sonal Panse

When I was seven, I decided I wanted to be an artist and a writer. I thought it would be an excellent way of finding out more about the world. It has since been a fine journey in staying balanced, making connections, and continually learning something new. I'm very happy to have such a creatively rewarding and fulfilling occupation.

I write children's books, YA books, NA books, graphic novels, and romance books, and I have a Sunday comic-strip 'The Smartist' if you haven't seen it yet, you should. I'm deeply interested in art, music, musical instruments, gardening, dog training, travel, languages, history, science, kind and humorous people, mindfulness, and lots and lots and lots of other things.

I have a Bachelor's Degree in History, a Master's Degree in English Literature, and a Diploma in Fine Art.

You can find me here -

Personal website – http://www.sonalpanse.com

Maysun In C Book Page - http://www.maysuninc.com/books

Amazon Author Page - http://www.amazon.com/Sonal-Panse/e/B00NK7NMM8

Twitter - http://www.twitter.com/MaysunInC

Facebook - http://www.facebook.com/MaysunInC

Comic-strip - http://www.maysuninc.com/illustration/story-comic-strip

Other Books

Children's Fiction

Tales of Princesses and Princes - Volume 1
Tales of Princesses and Princes - Volume 2

The Panchantantra Retold: Part 1 - Mitra Bheda
The Panchantantra Retold: Part 2 - Mitra Samprapti
The Panchantantra Retold: Part 3 - Kakolukiyam
The Panchantantra Retold: Part 4 - Labdhapranasam
The Panchantantra Retold: Part 5 - Apariksitakarakam

Coloring Books

The Gardens Of Quirly: A Coloring Book (The Quirly Coloring Books) (Volume 1)
The Men Of Quirly: A Coloring Book (The Quirly Coloring Books) (Volume 2)
The Women Of Quirly: A Coloring Book (The Quirly Coloring Books) (Volume 3)
The Dragons Of Quirly: A Coloring Book (The Quirly Coloring Books) (Volume 5)
The Birds Of Quirly: A Coloring Book (The Quirly Coloring Books) (Volume 6)
The Musicians Of Quirly: A Coloring Book (The Quirly Coloring Books) (Volume 7)

Coloring Fun Mandalas: A Coloring Book (Volume 1)
Coloring Fun Tangles: A Coloring Book (Volume 2)
Floral Tangles: A Coloring Book

Children's Picture Books

Learn to Read the Alphabet: Early Learning Series
Learn to Count Numbers: Early Learning Series

Visit www.maysuninc.com for information about all our books.
To be notified of our upcoming books, please sign up for our newsletter at -
www.maysuninc.com/newsletter

We will appreciate your feedback on Amazon and Goodreads.

www.ingramcontent.com/pod-product-compliance
Lightning Source LLC
Chambersburg PA
CBHW080536190526
45169CB00007B/2522